BNSF RAILWAY

Richard Billingsley

AMBERLEY

I'd like to dedicate this book to my Mum, Anne. Right or wrong, she's always been in my corner.

Thanks Mum.

First published 2019

Amberley Publishing
The Hill, Stroud
Gloucestershire, GL5 4EP

www.amberley-books.com

Copyright © Richard Billingsley, 2019

The right of Richard Billingsley to be identified as the Author of this work has been asserted in accordance with the Copyrights, Designs and Patents Act 1988.

ISBN 978 1 4456 8545 8 (print)
ISBN 978 1 4456 8546 5 (ebook)

British Library Cataloguing in Publication Data.
A catalogue record for this book is available from the British Library.

Typesetting by Aura Technology and Software Services, India. Printed in the UK.

Introduction

With operations spanning twenty-eight states and three Canadian provinces, more than 32,000 miles of track and trackage rights for several thousands more, the Burlington Northern & Santa Fe Railroad, known more often as the BNSF Railway, is the largest of the seven Class One freight railroads in the United States.

Its ancestry can be traced back to 1849 and the inauguration of the Chicago, Burlington & Quincy system in Illinois as the Aurora branch, and the start of the Atchison, Topeka & Santa Fe transcontinental railroad from Chicago to Los Angeles in 1859. Acquisitions and mergers over the years swallowed up more systems including the Frisco lines, the Great Northern and Northern Pacific railways and the Spokane, Portland & Seattle Railway, and by the 1980s the railroads had formed into two companies, the Burlington Northern Railroad and the Atchison, Topeka & Santa Fe Railway.

An ultimately unsuccessful take-over of the ATSF by the Southern Pacific in the mid-1980s, rejected by regulators as being monopolistic, left both companies in vulnerable positions; the ATSF system merged with the Burlington Northern to form the Burlington Northern & Santa Fe Railway in 1995 and the Southern Pacific became part of the Union Pacific in 1996. Some exchange of tracks and trackage rights between the UP and BNSF systems occurred after the mergers; this gives both companies access to more areas and markets throughout a large part of the south-west of the United States.

Headquartered in Fort Worth, TX, the modern-day BNSF operates around 8,000 locomotives and 90,000 freight cars; it further leases locomotives from other operators and leasing companies as required. In addition, many further thousands of freight cars are leased and used by both the railway and its customers. This equipment and around 41,000 employees operate over 1,400 trains a day, moving 10 million carloads of freight a year to twenty-five intermodal terminals, forty ports and a dozen hump yards, as well as to and from many hundreds of private customer terminals. The BNSF Railway is thought to move around a third of all intermodal traffic in the United States.

The focus of the BNSF Railway is its freight operations, but it also hosts the activities of other companies. The BNSF and Union Pacific both extensively use each other's tracks to access both customers and other parts of their systems; the trackage rights system allows both railroads to avoid long detours to reach distant parts of their own systems. An example of this is the BNSF use of the Union Pacific's Mojave sub allows traffic from Texas to the San Francisco Bay area to travel directly instead of having to travel north to Montana before returning south.

In common with other Class Ones, the BNSF Railway also hosts the long-distance passenger services of Amtrak, and the shorter operations of regional commuter operators including the Minnesota Northstar Line, Metrolink in southern California and Metra in Chicago. The company actually operates the BNSF Railway Line, one of the eleven Metra lines in the Illinois network. Amtrak services that utilise BNSF metals include the California Zephyr, the Coast Starlight and Texas Eagle services, as well as the West Coast Amtrak Cascades, San Joaquin and Pacific Surfliner services.

The railroad boasts a large variety of motive power; fleets of older, lower-powered locomotives have been retained for local and yard work, while recent locomotive purchases have tended to be larger, high-powered units such as the GE Evolution series and EMD SD70ACe locomotive. In common with other US railroads, the tendency is to operate long trains with several locomotives; a long intermodal may have only two units, although at least three is more common, while the heaviest trains, those conveying stone, oil, coal or grain, may have as many as ten locomotives, some at the front of the train, some at the rear and sometimes cut into the middle of the formation. The DPUs (distributed power units) are operated by a telemetry system from the leading locomotive.

Over recent years increases in traffic have prompted the ATSF and later the BNSF to adopt a policy of expansion. An emphasis has been placed on increasing capacity on the two major Trans-Con routes, doubling single-track routes, installing new or widening existing bridges where possible and replacing outdated signalling with new equipment. The Southern Trans-Con route from Chicago to Los Angeles is now double-track almost entirely throughout its 2,000 plus miles and at any time is reckoned to be hosting in excess of 300 trains. The only single track on the route is over two bridges and plans are in place to remove these bottlenecks while further work has started to add three and four-track sections in Texas, New Mexico and Arizona. Since the start of the expansion of the route by the Santa Fe in 1992, over 500 route miles have been upgraded from single to multiple-track.

The railroad has used several paint schemes since its inception, but most locomotives carry an orange, yellow and either dark green or black colour scheme; the earlier Heritage I and Heritage II schemes are still common, but the latest Heritage III scheme features the latest BNSF logo on both bodyside and locomotive nose. Pre-merger colour schemes still feature heavily. Some elderly Dash-9 locomotives carrying the ATSF Warbonnet red and silver colours are still seen on important intermodals, while much of the yard power fleet still carries the Bluebonnet blue and yellow scheme, often still carrying the Santa Fe name. Less common but still to be found are the green and white colours of the Burlington Northern Cascades scheme. Most of the BNSF fleet of EMD SD70MAC locomotives carry the green and cream BNSF Executive livery.

This book shows the BNSF at work in its heartlands, the mid and western United States from California to Arkansas and Idaho to Texas, highlighting its everyday operations and those involving other railroads.

Locomotive Designations

To the casual viewer or someone interested in trains who has little knowledge of American railroads, the designations used for differing motive power might seem bewildering. The following notes will help the reader to understand the different types of locomotives.

For much of the past forty years, the market in the US has been dominated by two manufacturers, Electro-Motive Division (EMD), a General Motors subsidiary until 2005 and now owned by Progress Rail, and General Electric (GE).

The larger of the two manufacturers is General Electric; they currently hold two-thirds market share. The current Evolution series started production in 2003 and over 5,000 units have been built. Some of the varying types are detailed below.

ES44DC – Evolution Series, 4,400 hp, DC traction motors
ES44AC – Evolution Series, 4,400 hp, AC traction motors
ES44C4 – Evolution Series, 4,400 hp, AC traction motors, A-1-A trucks with centre unpowered axle
ET44AC – Tier 4 Evolution, 4,400 hp, AC traction motors
ET44C4 – Tier 4 Evolution, 4,400 hp, AC traction motors, A-1-A trucks with centre unpowered axle

A letter H at the end of a designation indicates that the locomotive is a ballasted, heavier version with increased tractive adhesion, e.g. ET44AH instead of ET44AC. A CTE designation denotes use of controlled tractive equipment, similar to Sepex traction motors in the UK, e.g. C45ACCTE. The UK Powerhaul Class 70, PH37ACmi, is loosely based on the Evolution platform.

Many locomotives built before the Evolution series remain in use. These include the Dash-8 and Dash-9 series locomotives, C40-8W (4,000 hp Dash-8) and C44-9W (4,400 hp Dash-9). Both designs use DC traction motors; they were superseded by the AC4400C locomotives built with AC motors.

The second manufacturer is Electro-Motive. The company has produced locomotives since the 1930s and became the market leader, overtaking the American Locomotive Company (ALCO) in the 1960s. That dominance was lost to General Electric in the late 1980s, but EMD still produces much equipment for both domestic and international markets.

The GP (general purpose) locomotives are four-axle units built from 1949 to 1994 utilising EMD 567, 645 or 710 series engines. Many GPs have been rebuilt for extended service, and while their days of long-distance, high-speed work are long gone, they are still prolific on local trip workings and yard duty.

The SD locomotives (standard duty) are the larger six-axle units built from 1952 onwards using the EMD 265, 567, 645, 710 and 1010 series engines. The SD40 variant is basically a larger version of the GP locomotive, but the SD series has evolved to produce large, high-powered units such as the SD70ACe, in production since 2003. The Union Pacific was by far the largest customer for the SD70M; it purchased around 1,500 of the 4,000 hp locomotive.

The designations on EMDs differ to those on GE locomotives in that the numbering (SD40, SD60, etc.) refers to SD models rather than engine output. SD units up to the SD60M and SD70M have DC traction motors; the SD60MAC and SD70MAC variants were the first to offer AC equipment. The SD70MAC was replaced in 2003 by the SD70ACe, which is now the standard EMD heavy-hauler; its latest guise is the SD70ACe-T4, which complies with Tier 4 emissions legislation.

SD locomotives in current use vary from the 3,000 hp SD40, 3,800 hp SD60 and 4,000 hp SD70M to the 4,300 hp SD70ACe and 6,000 hp SD90MAC.

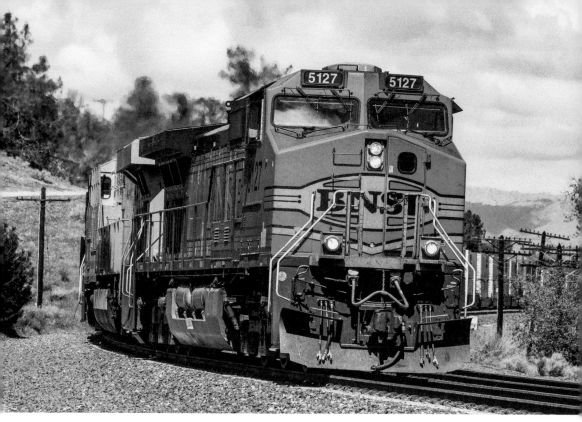

Working hard to combat the 1 in 40 adverse gradient, GE C44-9W No. 5127 leads a train of intermodal boxes around the curves at Keene, CA, on 1 April 2014. The second locomotive is a hired-in GE unit belonging to the Citirail fleet, carrying the company's grey and yellow colour scheme.

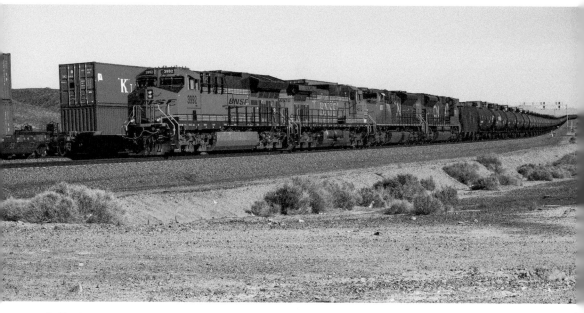

Bulk oil trains are a frequent sight throughout the BNSF network. This train also features borrowed motive power with two Canadian National EMD locomotives being led by ET44C4 No. 3992 and C44-9W No. 4970. The westbound train was captured on the BNSF Trans-Con at Daggett, CA, on 31 January 2017.

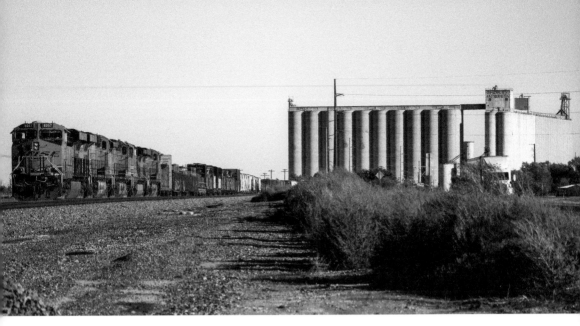

Parked alongside the Sherley Anderson grain elevators at Parmer, TX, this westbound manifest was awaiting the arrival of a relief crew when seen on 26 October 2017. The crew will arrive by road from the nearby BNSF facility in Clovis, just across the state line in New Mexico.

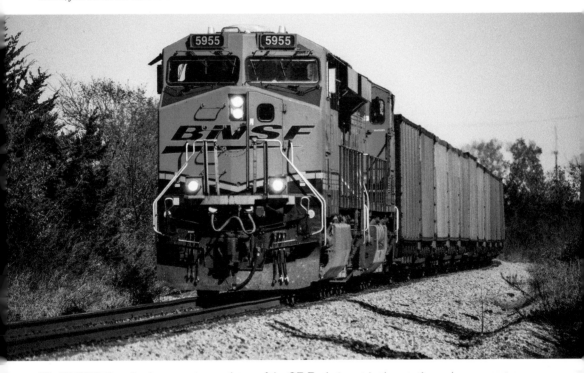

The BNSF Railway has been a major purchaser of the GE Evolution series locomotive and now operates over 3,000 units. Typical of its type, ES44AC No. 5955 leads a long train of stone hoppers south from Ada, OK, on 24 October 2017.

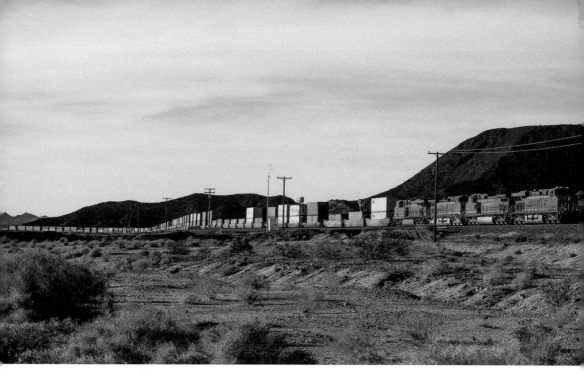

The BNSF Southern Trans-Con links the south-west US with the Midwest and Chicago and has huge strategic importance to the economy of the entire union. Many of the trains that utilise the line are high-importance intermodals, usually double-stacked to maximise the payload. This eastbound was caught deep in the Mojave Desert at Siberia, CA, on 4 February 2017.

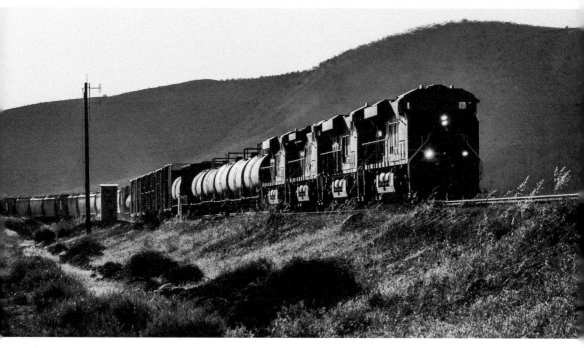

With a watery sunset highlighting the side details of its motive power, a train heads into the Tehachapi Mountains at Bena, CA, on 5 July 2013. The Union Pacific-owned route through the Tehachapis is used by the BNSF on a trackage rights agreement.

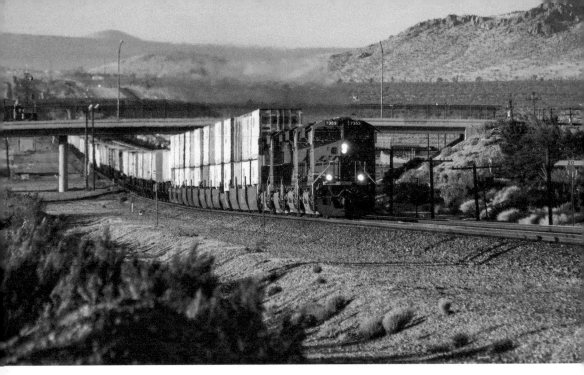

Having raced across the west Mojave Desert from Barstow, CA, this intermodal now faces the stiff 20-mile climb into the Tehachapi Mountains from the south. Rising at 1 in 43, ES44DC No. 7353 leads three more units and a long domestic intermodal out of Mojave, CA, on 21 June 2012.

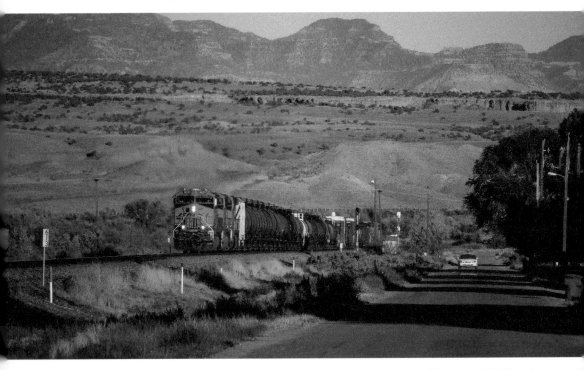

The mountains dwarf a BNSF manifest train at Wellington, UT, on 13 September 2018. This former Rio Grande Western route is Union Pacific-owned but also hosts traffic from the BNSF, Amtrak and the Utah Railway. ES44C4 No. 6571 leads the train west.

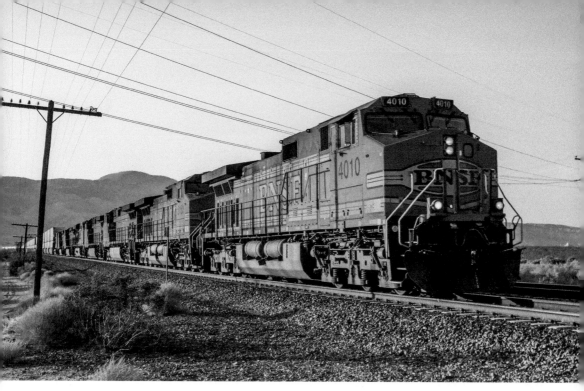

Under a net of utility and telegraph wires, C44-9W No. 4010 drops down into Mojave, CA, at the head of an intermodal led by eight units on 4 July 2013. Service trains are often used to transfer locomotives needed for use elsewhere; in this instance only the front three units were under power.

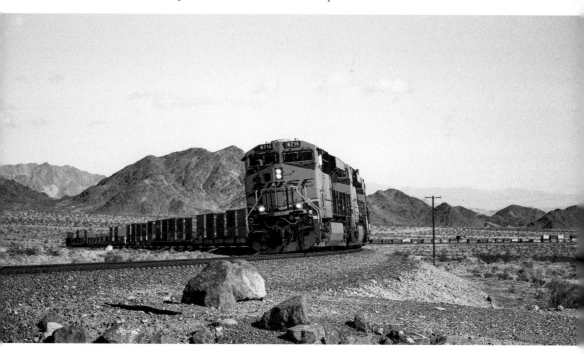

Amid spectacular desert scenery, a long train of double-stack intermodal boxes winds upgrade at Siberia, CA, on 9 February 2019. The short but sharp climb out of the Amboy Crater reduces the speed of heavy westbound trains to little more than walking pace at this point. Seven-year-old ES44C4 No. 6715 leads the train.

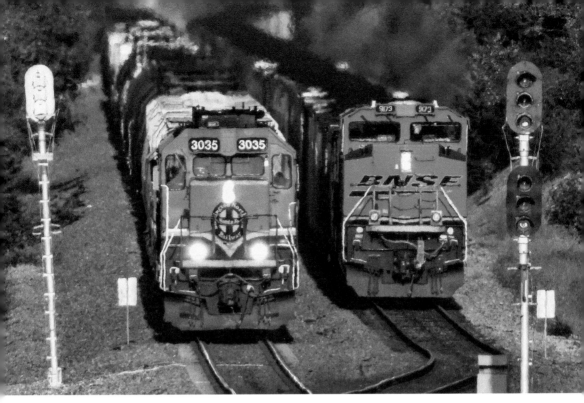

Above: A hot afternoon at Pleasant Dale, NE, on 28 September 2015 sees GP40X locomotive No. 3035 awaiting the passage of the long train of Powder River Basin coal heading east with SD70ACe No. 9153 helping at the rear. The BNSF has preferred GE locomotives over those of EMD in recent years; despite this the company still runs over 650 SD70ACe units.

Below: Seen at Barrio Logan in the heart of San Diego's dockyards, No. 114 is an EMD GP60M locomotive new to the ATSF in 1990 and carries the current Heritage IV paint scheme. Pictured on 1 February 2019, the locomotive and the fine red Santa Fe caboose are used to shuttle cars to and from the Mexican border at San Ysidro, a few miles to the south.

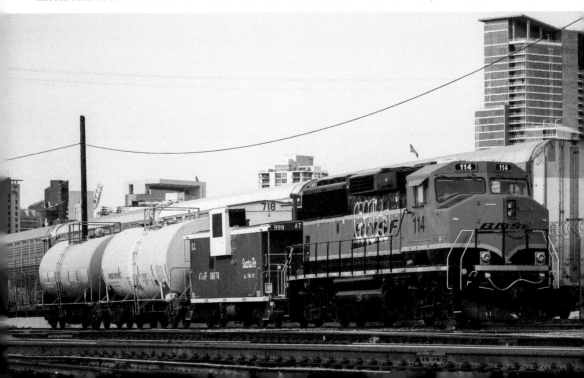

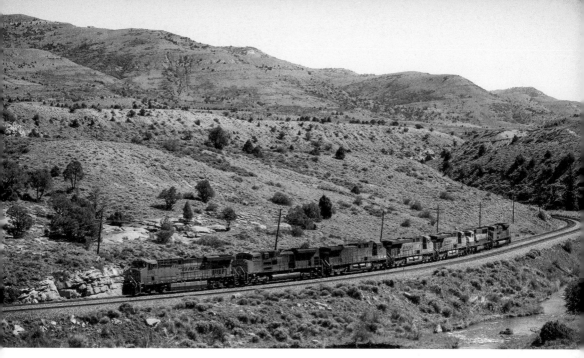

Above: Making progress towards Soldier Summit, this septenary of BNSF power includes four GE locomotives and three from the rival EMD stable. Note the SD70MAC, No. 9706, in BNSF green and cream Executive livery; many of these units are now being retired by the railroad. Colton, UT, 13 September 2018.

Below: A full-frontal view of ES44DC No. 7314 at Tehachapi Summit, CA, on 22 June 2012. It is a frequent sight to see northbound trains waiting at the summit – there are several stretches of single-track railway as the line drops down into the Central Valley which frequently cause congestion between here and Bakersfield, 40 miles to the north.

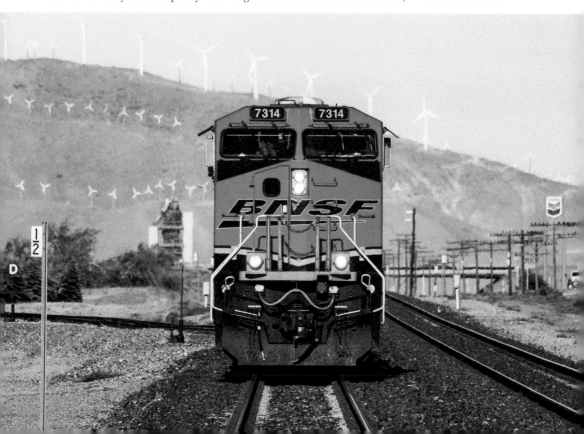

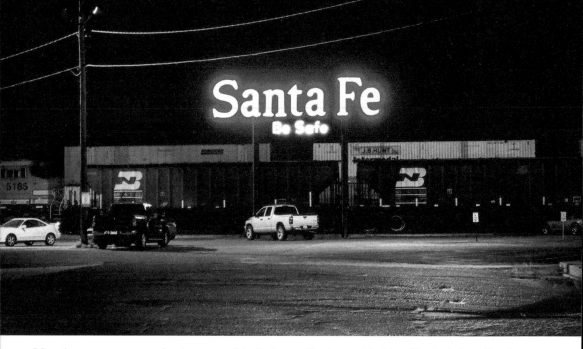

More than twenty-one years after the merger of the Burlington Northern and Atchison, Topeka & Santa Fe railways, evidence of both systems was still to be seen at the highway entrance to the BNSF yard at Clovis, NM, on 26 October 2017, Burlington Northern wagons spending the night under the warm glow of the splendid Santa Fe neon welcome sign.

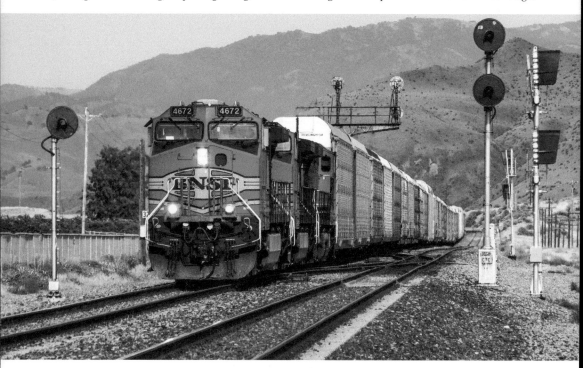

During 2013, the Union Pacific replaced the old searchlight signalling on the Mojave sub with modern LED-based equipment. The older system was still in use as C44-9W No. 4672 leads a train of auto-racks north through Sandcut, CA, on 5 July 2013.

Rattling eastbound through Kingman, AZ, ES44C4 No. 8174 leads four C44-9Ws and double stacks into the night on 28 January 2017. Kingman is a great location for 'golden hour' shots before sunset – the line takes several twists and turns as it passes through the town.

During late 2015 and early 2016, the Los Angeles Metrolink system hired a substantial number of BNSF AC4400CW locomotives after concerns were raised about the ability of Metrolink's Hyundai Rotem cab cars to deflect obstacles from the track in a collision. No. 5627, seen at LA Union station on 6 March 2016, is alongside one of the errant cars.

The Southern Trans-Con bisects the Mojave Desert for many miles through eastern California. This is Ash Hill between Barstow and Needles; the railroad cuts through volcanic rock formations as it reaches the end of the ascent from Siberia. ES44DC No. 7655 brings a train west on 2 February 2017.

Sitting square on the Kansas–Missouri state line, Santa Fe Junction is a complex interchange of lines to the south-west of downtown Kansas City. Several railroads pass through, including the BNSF, Union Pacific and Amtrak. ES44AC No. 6259 passes underneath a train rolling east over elevated lines. 27 September 2015.

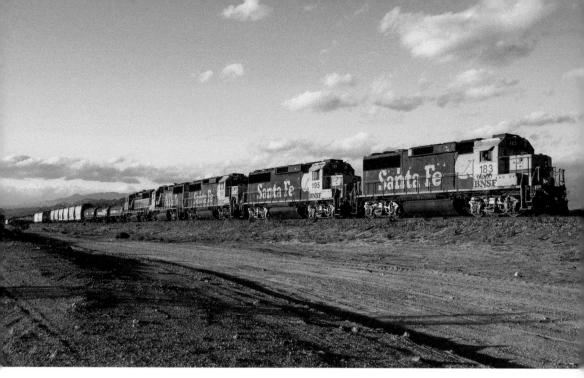

The Cadiz local, a train that takes traffic for the Arizona & California Railroad from Barstow to Cadiz, CA, is well known for four-axle locomotives and their various liveries. 10 February 2019 didn't disappoint with four Bluebonnet GP60s and a single Heritage IV-liveried GP60M. At the Cadiz exchange track, locomotives Nos 183, 195, 189, 185 and 151 deliver the train for the ACR to collect.

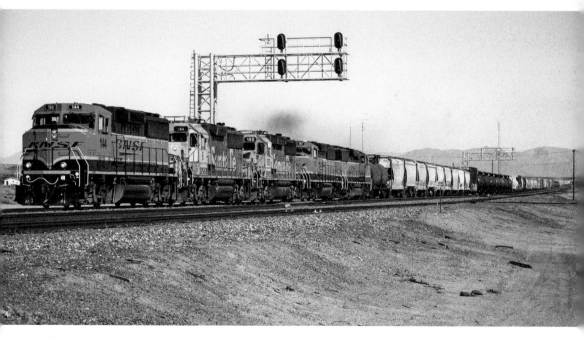

Another view of the Cadiz local, this time seen returning home to Barstow along the Southern Trans-Con at Amboy, CA, on 18 September 2018. GP60M No. 144 leads, followed by two GP60s, Nos 164 and 180, followed by GP60M's Nos 157 and 101. The older units are slowly receiving Heritage IV colours, but plenty are still carrying older Santa Fe liveries.

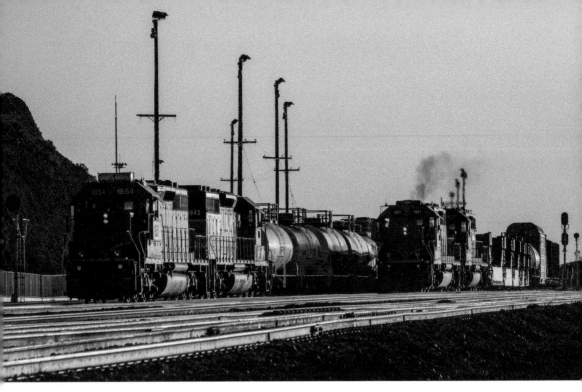

Sunset switching at Barstow's East D Yard on 7 April 2014. Two pairs of SD40-N locomotives, Nos 1854 and 1843 and Nos 1851 and 1707, are remotely controlled during switching operations; the locomotive controller is based in the yard tower around half a mile to the east.

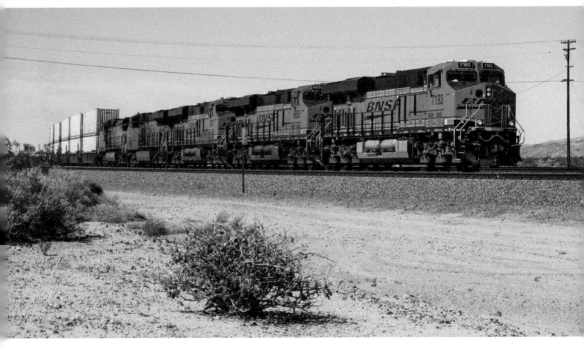

Sweeping away from Barstow, an eastbound intermodal takes the curve at Daggett, CA, on 10 March 2016. The front three locomotives are all ES44C4s, carrying the Heritage III livery from new, although No. 7193 is around four years younger than the other two.

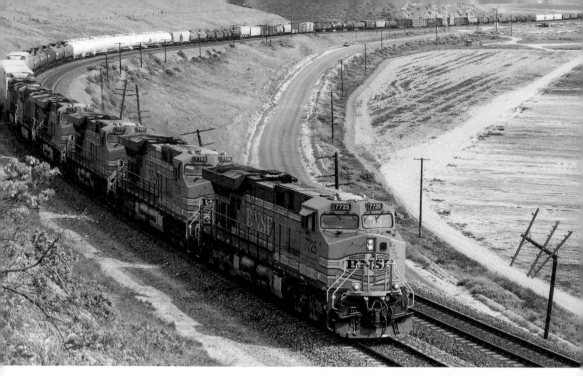

In this shot the first four locomotives, ES44DCs, are all from the same batch delivered in 2005. The locomotives have carried the Heritage II livery scheme from new and are seen at Sandcut, CA, on 28 February 2016. With a vast operating area and 8,000 locomotives, it is quite unusual to see locomotives from the same batch operating together.

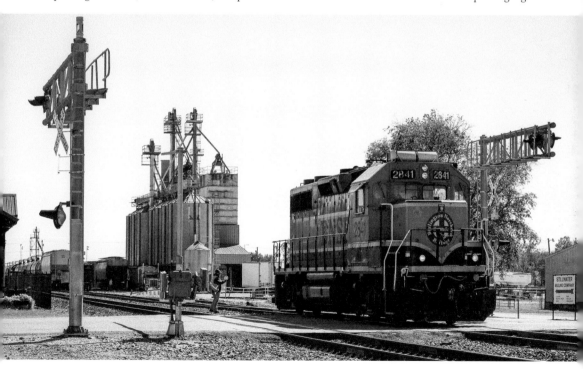

Blocking the main street through town, GP39-3 No. 2841 brings Davis, OK, to a stand as it engages in collecting a handful of hopper wagons from the grain elevators on 25 October 2017. Although currently slightly declining, this type of pick-up goods train is still very common throughout the United States.

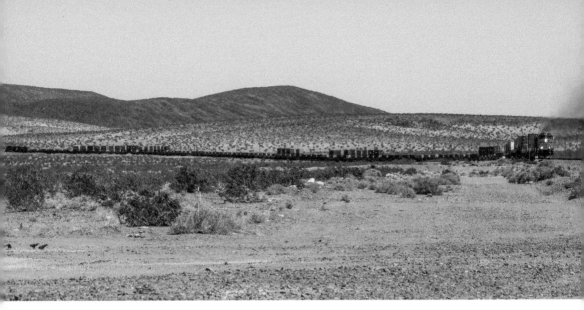

With the 30-mile climb from Amboy almost complete, a train of westbound double stacks approaches the desert oasis of Ludlow, CA, on 7 April 2014. Much of the next 50 miles is over relatively flat terrain before the line drops into the important junction and yards at Barstow.

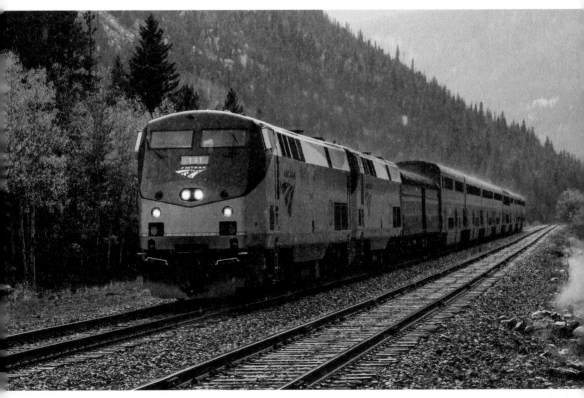

Amtrak passenger trains extensively use the tracks of the BNSF Railway. Captured at Tolland, CO, on 3 October 2015 with GE Genesis P42DC locomotives Nos 131 and 205 in charge, the eastbound California Zephyr has just passed through the 6-mile-long Moffat Tunnel. The train is around 22 hours and a thousand miles from its Chicago destination.

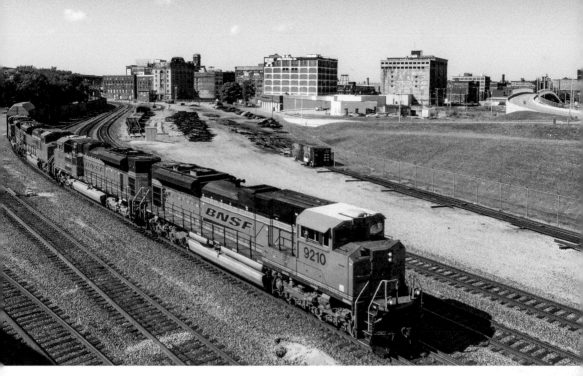

Running through the West Bottoms district of Kansas City, MO, four BNSF SD70ACe locomotives bring a loaded coal train through semi-derelict warehouses and long forgotten buildings typical of this area of town. The Kansas–Missouri state line is at the other end of the train. 27 September 2015.

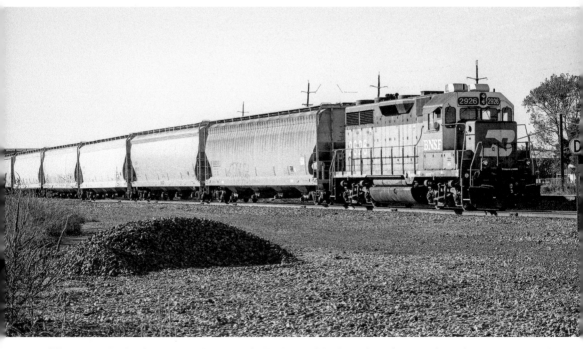

There are still a few locomotives that carry the Burlington Northern Cascades green livery, but retirements and repaints reduce that number each year. Seen at Iowa Park, TX, on 24 October 2017, No. 2926 is an elderly GP39E that was new to the Great Northern Railway in 1964.

Ambling east, a pair of GE locomotives take a very short intermodal past Taiban, NM, on 27 October 2017. Carrying just ten containers, it is likely that the three well car sets had been detached from an earlier service due to a car fault or an insecure load.

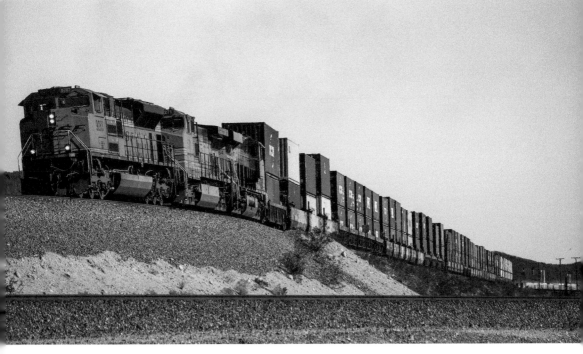

BNSF SD70ACe locomotives do not figure very much on intermodal traffic through the Mojave Desert, the railroad preferring their use on heavy aggregate and coal traffic. They do appear from time to time, though; this is No. 9283 at West Siberia, CA, on 10 February 2019, leading its load west.

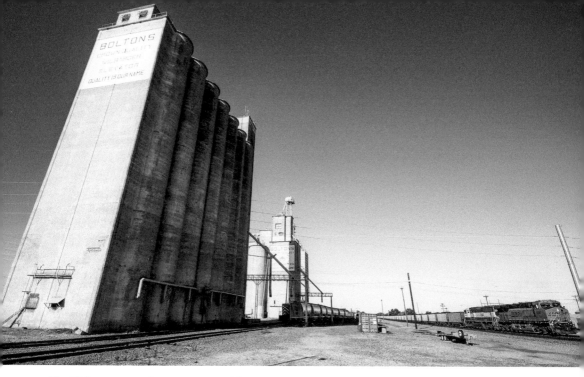

The Wilbarger grain elevator at Vernon, TX, stands next to the BNSF tracks through the town and still uses the railroad to move its goods. Long coal trains feature; this southbound load was being taken through Vernon by ES44AC No. 6287 and SD70MAC No. 9540 at breakfast time on 26 October 2017.

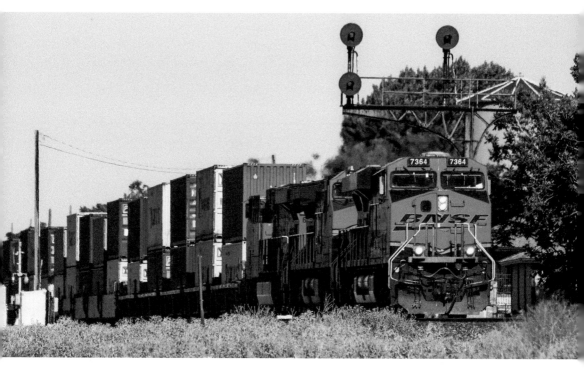

The Southern Pacific signal cantilever situated on the tracks outside the depot at Tehachapi, CA, was famed in its later years as being one of the last of its type in the area. Seen with ES44DC No. 7364 underneath on 21 June 2012, it was uprooted from its seventy-year home on 1 May 2013.

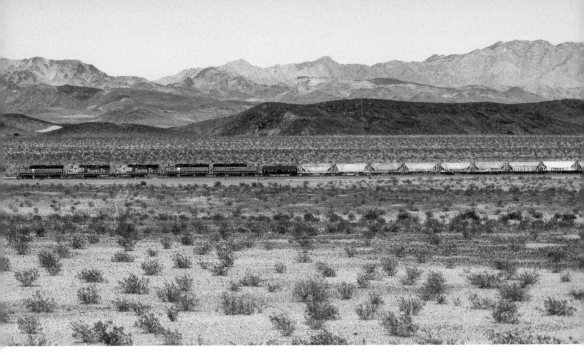

The Cadiz local and its four-axle locomotives, this time seen on the homeward-bound journey, returning cars from the Arizona & California Railroad to the BNSF classification yard at Barstow, CA. Three Heritage IV-liveried GP60Ms sandwich two Bluebonnet GP60s at Ash Hill, CA, on 18 September 2018.

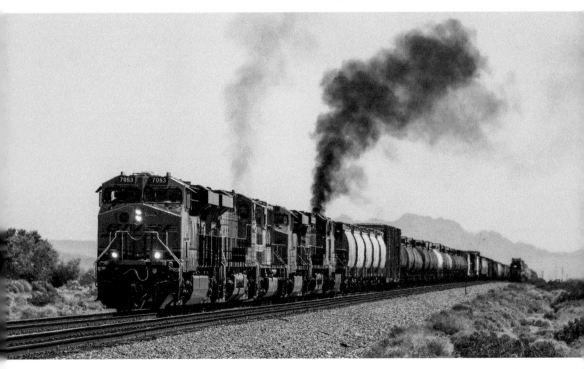

With one of its six locomotives clearly not in the best of condition, a Trans-Con manifest re-starts from a signal stop west of Newberry Springs, CA. Loss of a faulty unit here wouldn't hinder progress – the BNSF has a diesel shop at nearby Barstow which could supply a replacement if needed. 7 April 2014.

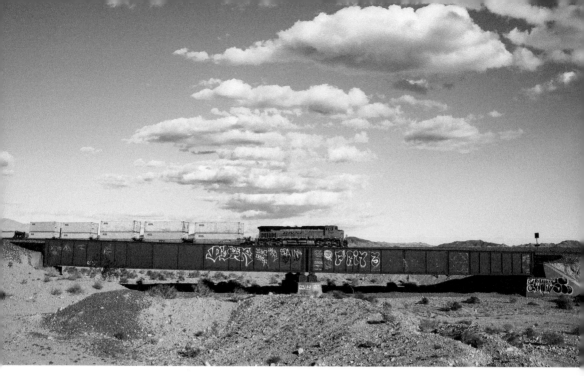

Despite appearances, ES44DC No. 7491 is not on the bridge at West Siberia, CA. The bridge carries the eastbound track; the westbound locomotive is pushing the train on an embankment behind. At this point, the two tracks take their own separate courses, rejoining at Klondike, 5 miles to the west. 9 February 2019.

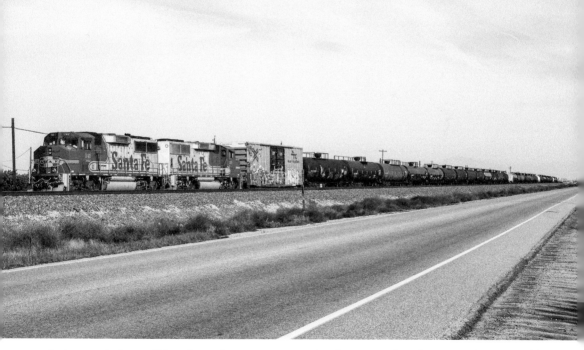

A photograph that could have been taken twenty years earlier than it was, the only giveaway being the BNSF lettering below the numbers of very tidy looking GP60Ms Nos 141 and 119. Seen at Crome, CA, on 8 April 2014, the red and silver Santa Fe Warbonnet colours have stood the test of time.

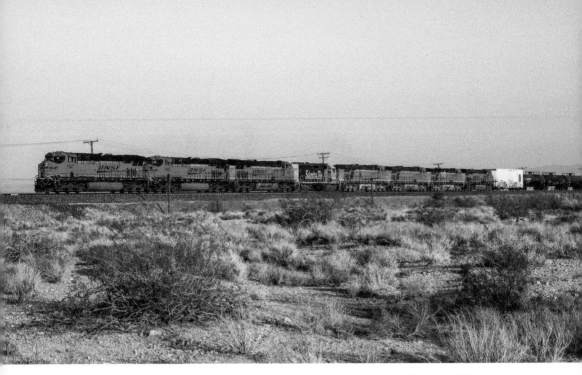

It looks like there's eight locomotives slugging oil cans up the hill at Fram, CA, on 4 July 2013. The reality is that only the front three units are at work; the Bluebonnet and everything behind are just units on power transfers to the San Francisco Bay area.

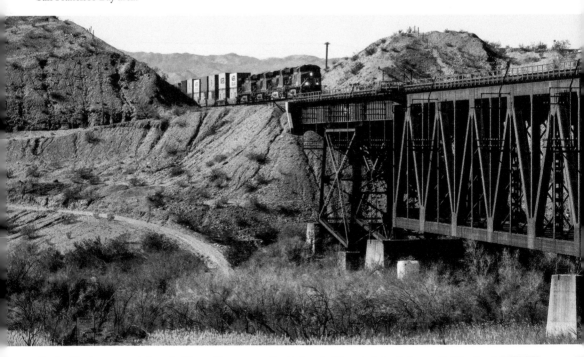

Bridged by immense girders, the Trans-Con crosses the Colorado River and the Arizona–California state line at Topock, a few miles to the east of Needles, CA. This is the view looking from Arizona to California on 29 January 2017 as four units take a colourful variety of double stacks east.

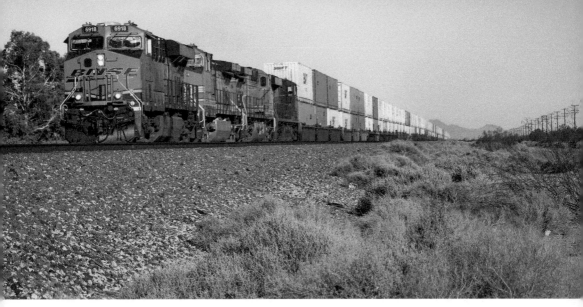

On 19 September 2018, ES44C4 No. 6918 leads eastbound stacks at Minneola Road to the east of Barstow, CA. A 3-mile drive north along Minneola Road will bring you to another grade crossing: the Union Pacific route from Salt Lake City and Las Vegas crosses as it heads south to join the BNSF tracks at Daggett.

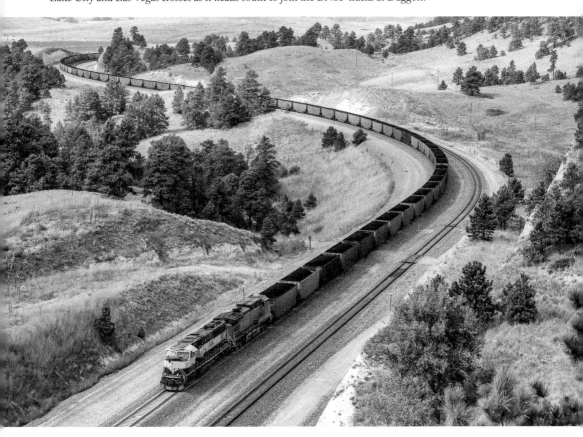

Around 8 miles to the south of Crawford, NE, is Crawford Hill; long trains of Powder River coal snake around the natural obstacle as they grind upgrade as part of their journey south and east. Displaying its BNSF Executive livery, locomotive No. 9699, an EMD SD70MAC from 1996, heads a train around the hill on 1 October 2015.

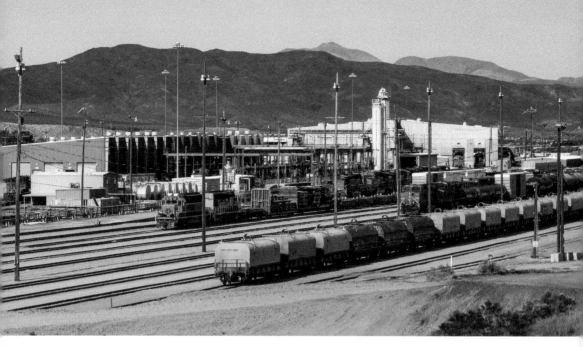

At the west end of the classification yard at Barstow, CA, lies an extensive diesel shop facility. This supplies locomotives for trains that are reformed in the yard as well as for local workings. The shop is seen on 4 April 2014 with a good selection of locomotives and wagons awaiting their next duty.

The rather faded Heritage II colours of C44-9W No. 5397 are seen to good effect above Caliente, CA, on 23 June 2012. The 'cigar band' BNSF device across the locomotive nose is a hangover from Santa Fe days that was modified and utilised on the Heritage I and II liveries.

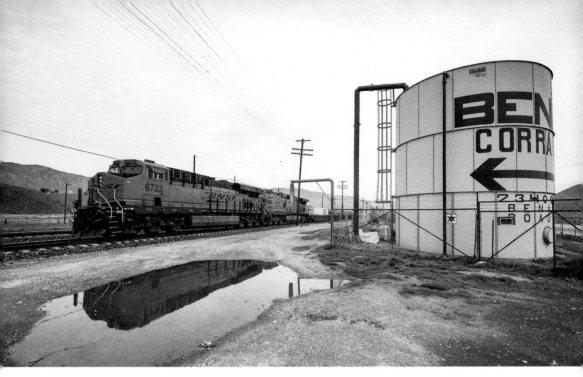

ES44C4 No. 6723 passes the water tank that supplies the cattle at Bena Corral, CA, on 12 February 2019. Behind the tank once stood a fertilizer works served by the railroad. Closed in the mid-1980s, it stood derelict until demolition in 2016.

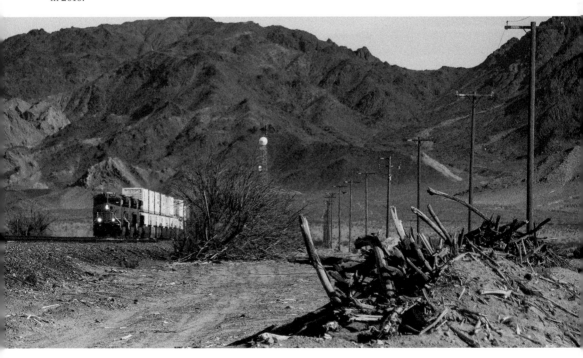

Although Cadiz, CA, is way out in the wilds of the Mojave Desert, it does sometimes see considerable rainfall. The autumn of 2014 saw major flash floods across San Bernardino County, causing the closure of many miles of Route 66 due to damage to bridges and culverts. These westbound double stacks pass some of the debris that remained on 30 January 2017.

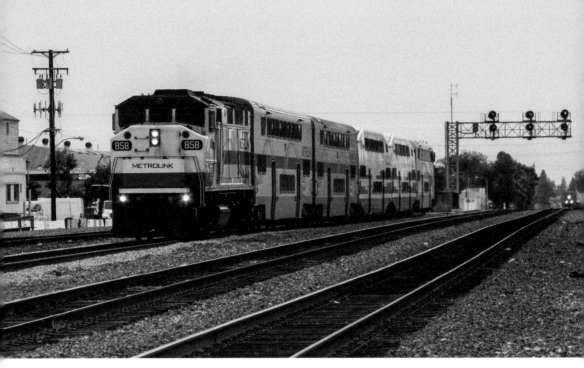

Metrolink EMD F59PH No. 858 approaches Fullerton, CA, on 12 July 2013 with a train of double-deck commuter stock from LA Union. This is BNSF track; an intermodal can be seen in the distance. Some F59PH locomotives are now being replaced by new EMD F125 Spirit locomotives.

The Mother Road, Route 66, and the BNSF Trans-Con shadow each other for many miles across the Mojave Desert. Route 66 is quiet and generally only used by locals and tourists, through traffic using the nearby I-40 Interstate instead. Rails and road meet at Siberia, CA, on 10 April 2014.

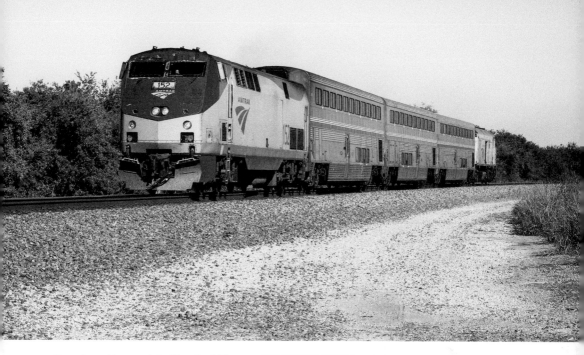

Above: Amtrak's once-daily Heartland Flyer passes Valley View, TX, on its morning southbound run from Oklahoma City to Fort Worth on 17 October 2017, powered by GE Genesis P42DC No. 152. With both locomotives and stock approaching the end of their service with Amtrak, options for replacement are currently being examined.

Right: Nebraska Highway 2 keeps close quarters with the BNSF Sandhills sub as they cross the often-desolate landscape in the western end of the state. The rear end of an eastbound coal train with a single DPU passes a highway marker near Whitman on 30 September 2015.

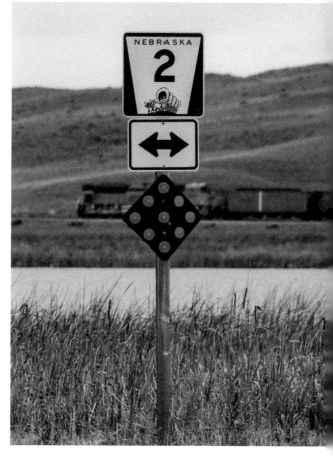

Above: The yard and telegraph office at Ada, OK, host GP39-2 No. 2780 and GP38-2 No. 2040 on 25 October 2017. South-west of Oklahoma City, although unconnected by rail, Ada lies on the old Frisco System route from Tulsa, OK, to Dallas, TX.

Below: A northbound double-stack intermodal breasts the summit at Tehachapi, CA, on 7 April 2014. Having climbed for around 20 miles from Mojave, the train now faces a 20-mile descent, which includes the world-famous Tehachapi loop, before reaching the relatively easy terrain of the Central Valley to continue north.

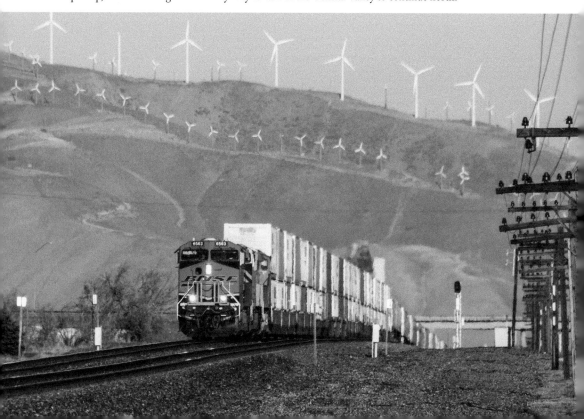

Above: High up in the Rocky Mountains near Tolland, CO, ES44C4 No. 7176 leads a westbound manifest on 3 October 2015. Shortly, the train will traverse the 6-mile-long Moffat Tunnel, built in the 1920s to replace the previous route, which went over the top of the mountain.

Below: 2 February 2017 sees eastbound stacks on the Trans-Con at Bagdad, CA. The eastern section of the Trans-Con in California, from Barstow to Needles, was originally constructed in 1882–3 by the Southern Pacific, which sold the route to the ATSF in 1884.

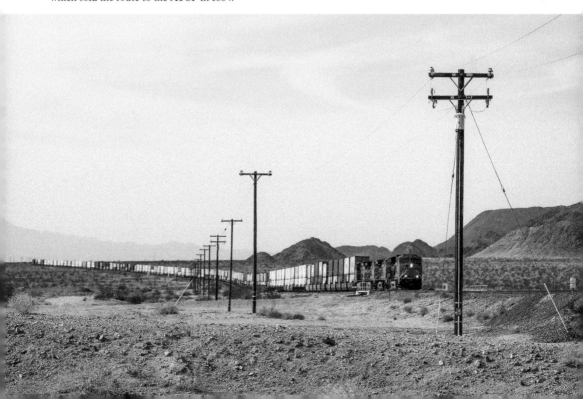

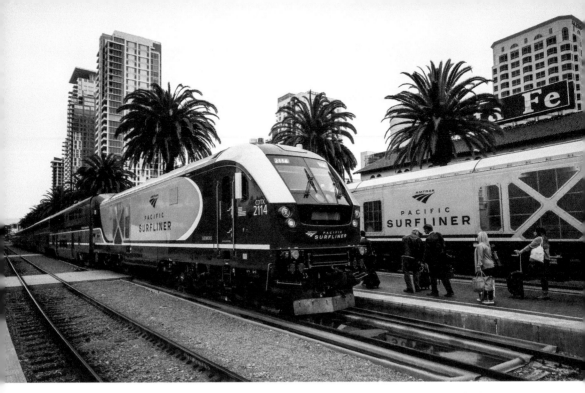

The former Santa Fe depot in San Diego, CA, is the southern terminus of the busy Amtrak Pacific Surfliner services from Los Angeles and Santa Barbara. BNSF trains still pass but are generally restricted to night-time running when there is no passenger service. Siemens SC-44s Nos 2114 and 2118 wait at the depot on 1 February 2019.

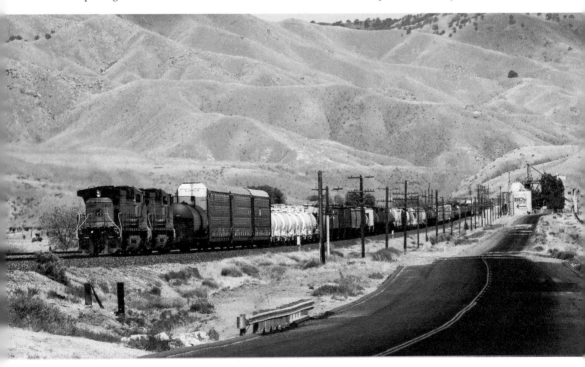

The Tehachapi Mountains loom large as a southbound manifest runs alongside Bena Road on 5 July 2013. The Union Pacific-owned route carries around twice as many BNSF trains as those of its owner.

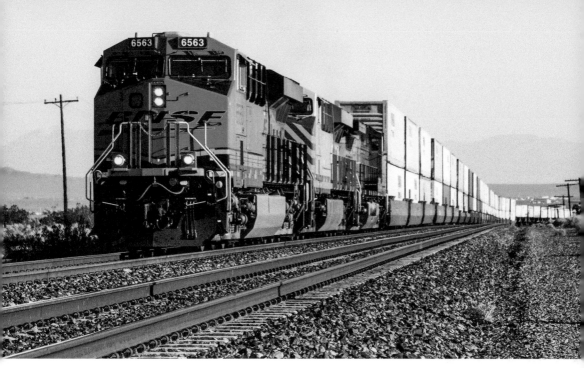

The BNSF carries thousands of the JB Hunt Group's white intermodal containers daily and they are a common sight on trains throughout the US. ES44C4 No. 6563 lifts another load north from Mojave, CA, on 6 April 2014.

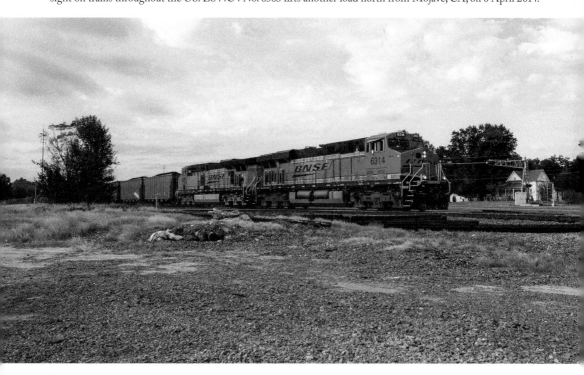

Using tracks owned by the Kansas City Southern Railroad, loaded coal trucks roll through Vandervoort, AR, with Nos 6314 and 5967, both ES44ACs, in charge on 20 October 2017. The sidings in front of the train once served a large saw mill.

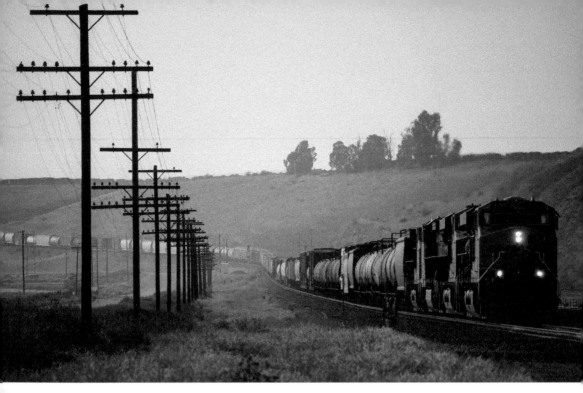

While held awaiting opposing traffic on the single-line section in front, the crew of this manifest takes the opportunity to have a few minutes away from the office on 28 February 2016. A few miles south of Bakersfield, CA, trains are often stacked here awaiting a clear run at the mountains ahead.

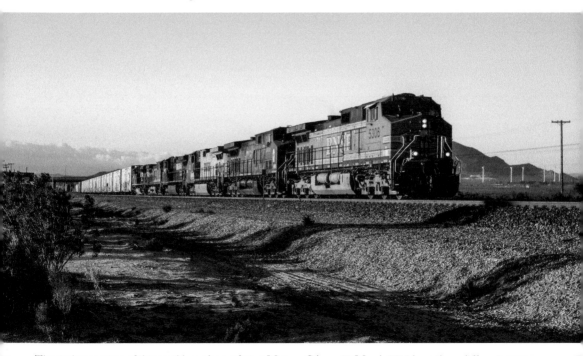

The six locomotives of this northbound manifest at Mojave, CA, on 30 March 2014 have three different owners and carry four different liveries: BNSF Heritage II, Canadian Pacific, Santa Fe Warbonnet and Norfolk Southern. Hiring of other railroads' equipment is a common practise throughout the country.

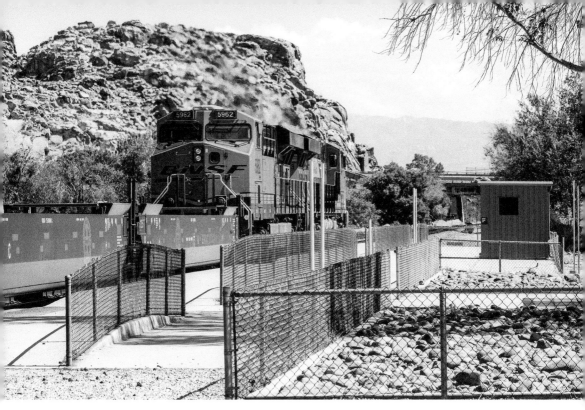

The rather basic facilities of the Amtrak station at Victorville, CA, are passed by a train of empty well cars on 3 April 2014; ES44AC No. 5962 is nearest to the camera. Served by the Southwest Chief since 1994, the station forms part of the Victor Valley Transit Centre, also served by local buses and Greyhound long-distance services.

Trailers on flat cars (TOFC) form an important part of the BNSF business; major customers include FedEx and Amazon. Split trains of containers and TOFC are a common sight, such as this westbound on the Trans-Con west of Newberry Springs, CA, on 1 February 2017.

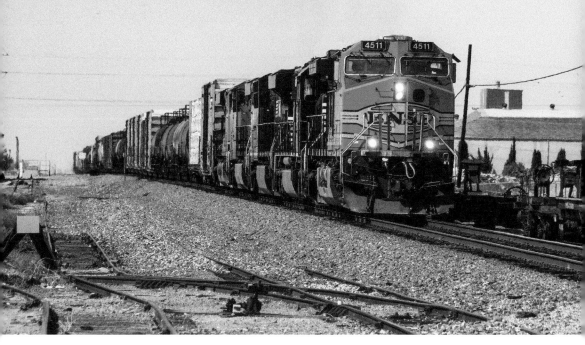

C44-9W No. 4511 leads a southbound manifest through abandoned sidings at Wasco, CA, on 8 April 2014. Wasco lies on the BNSF route north from Bakersfield to the San Francisco Bay area, the Union Pacific taking a more easterly course north from Kern Junction, south of Bakersfield.

A twilight meeting on the curves at West Siberia, CA, sees the eastbound Cadiz local meeting with a westbound intermodal on 2 February 2017. The somewhat careworn Santa Fe Warbonnets leading the local contrast sharply with the uniformity of the three modern Heritage III-liveried Gevos on the container train.

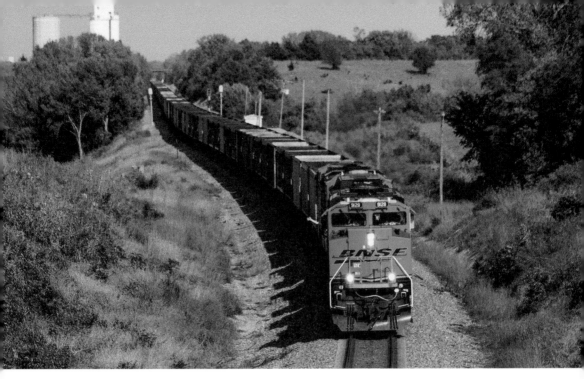

The movement of coal from mine to consumer inevitably leads to trains of empty cars returning to the mine for refilling. SD70ACe No. 9128, westbound at Pleasant Dale, NE, on 28 September 2015, will eventually head north to the vast coal mining area on the Powder River Basin in northern Wyoming.

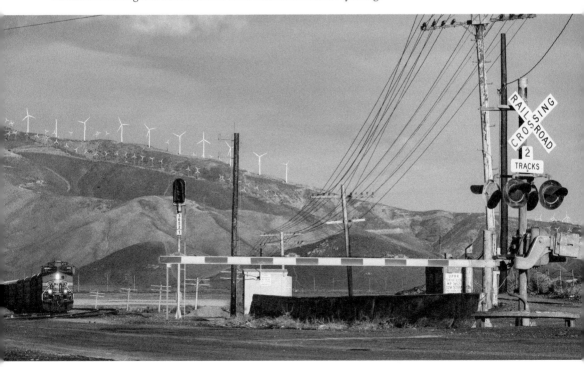

As on all US rail routes, grade crossings feature heavily on the BNSF even though the railroad has closed around 3,000 of them in the last twenty years. A train of auto-racks passes the crossing at Monolith, CA, on the UP-owned Mojave sub on 30 March 2014.

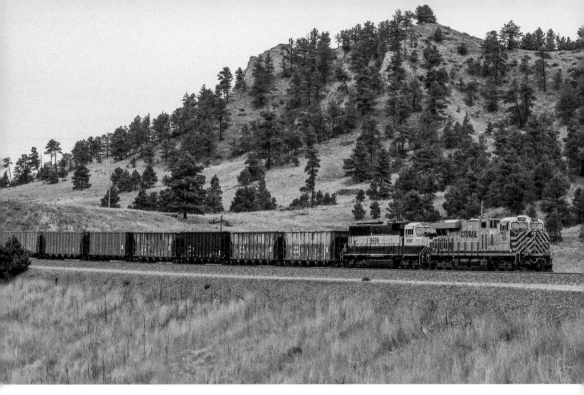

North America has a huge railroad equipment leasing business; many freight cars are owned by companies separate to the railroads and their customers. Locomotive leasing is commonplace as well – this caters for the seasonal peaks in traffic. Citirail-owned ES44AC No. 1423 leads SD70MAC No. 9599 on coal duty at Crawford Hill, NE, on 1 October 2015.

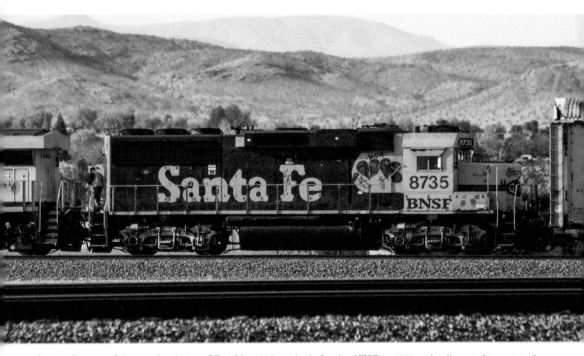

Seen at Barstow, CA, on 4 April 2014, GP60 No. 8735 was built for the ATSF in 1989 and still carried its original Bluebonnet paint scheme. Since the photograph was taken, the locomotive has been renumbered to 193.

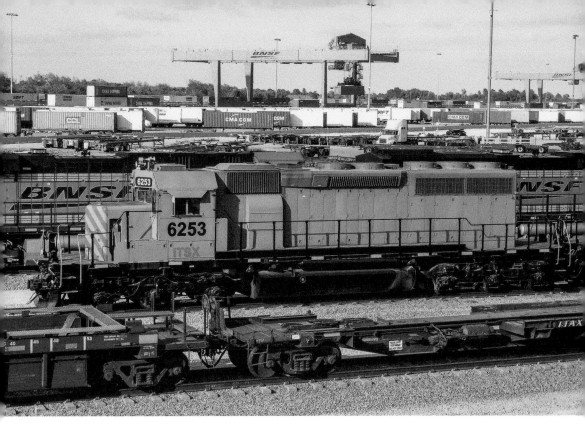

Owned by InTerm Service Technologies & Logistics, No. 6253 is an SD40-2 built for the Union Pacific in 1974. The locomotive is seen at the huge BNSF logistics park at Edgerton, KS, on 9 October 2015. ITSX is the four-letter American Association of Railroads identification code for InTerm Service.

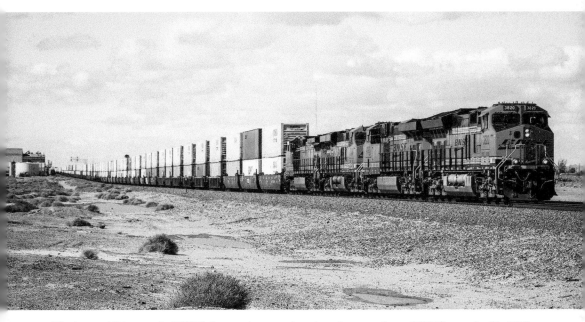

The latest additions to the BNSF's locomotive roster have been large numbers of GE Gevo units. No. 3820, seen heading east on the Trans-Con at Newberry Springs, CA, on 9 February 2019, is an ET44C4 built in 2016 to Tier 4 emissions standards.

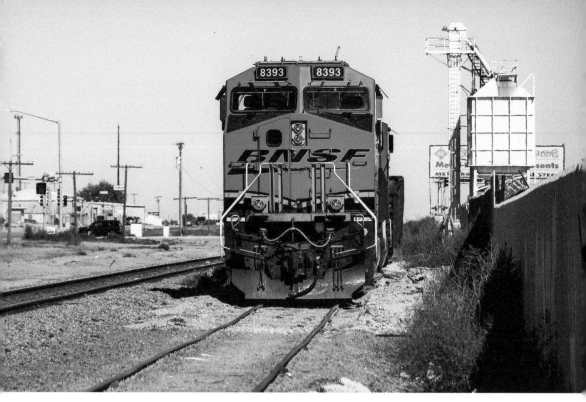

A quiet Sunday morning, 30 October 2017, at Artesia, NM, with ES44C4 No. 8393 awaiting its next duty. This line, from Clovis to Carlsbad, was leased to the Southwestern Railroad but returned to BNSF operation earlier in 2017.

To celebrate its 40th anniversary in 2011, Amtrak painted several P42DC locomotives in heritage colours. Seen on BNSF tracks at Wasco, CA, on 8 April 2014, No. 156 proudly displays the Phase 1 Bloodnose livery from 1972 while on a San Joaquin service from Bakersfield to Oakland.

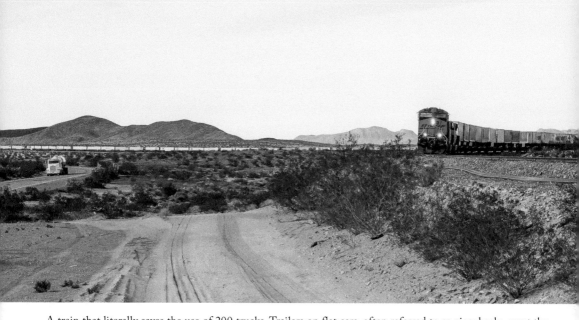

A train that literally saves the use of 200 trucks. Trailers on flat cars, often referred to as piggybacks, meet the competition on Route 66 on 10 March 2016. This train would have originated in Los Angeles and will use the Trans-Con to reach Kansas or even Chicago, over 2,000 miles distant.

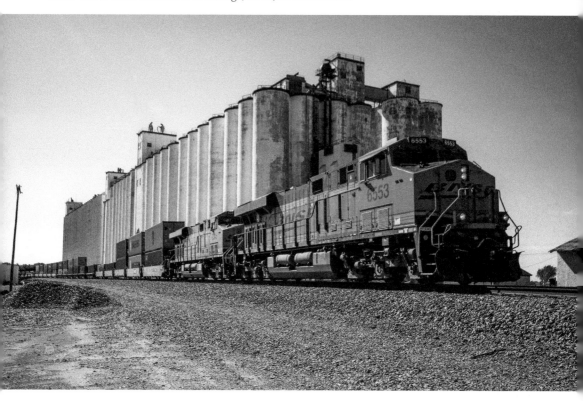

Huge grain elevators such as this one at Bovina, TX, are a common sight trackside, placed there for obvious reason; many are still served by the railroads. ES44C4 No. 6553 passes with eastbound Trans-Con containers on 27 October 2017.

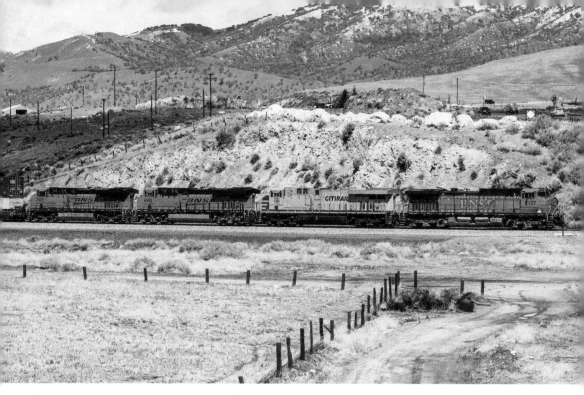

Despite being a desert region, the Tehachapi Mountains of California do see snowfall on occasion, most commonly in the late winter or very early spring. Typical of this is the scene from April Fool's Day of 2014 with four GE units making the final ascent into the City of Tehachapi with double stacks in tow.

A vital part of any railroad operation is its maintenance of way department, responsible for the upkeep of track, signals and structures. A quiet moment at Belmont, NE, allows a crew to work on switch maintenance as a pair of helper locomotives drift back down to Crawford after assisting a coal train uphill. 1 October 2015.

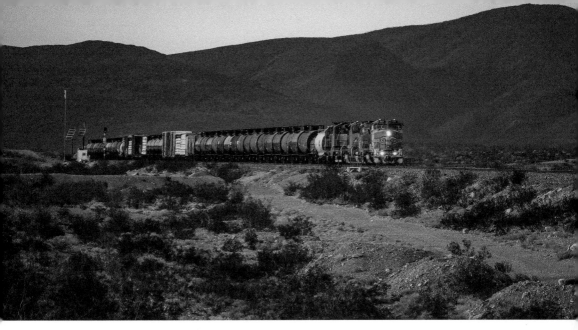

With black volcanic mountains looming behind, the Cadiz local and its usual eclectic mix of four-axle locomotives is led down from Siberia towards Amboy, CA, by B40-8W No. 552 on 30 January 2017. Now approaching thirty years in service, few Dash-8s remain on the BNSF locomotive roster.

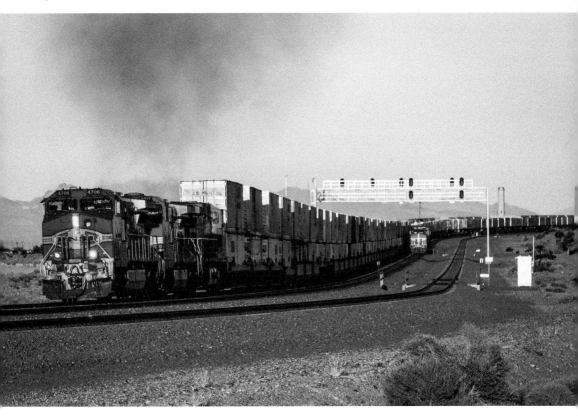

The successful Dash-9 series of locomotives are the predecessors of the current Evolution locomotives and the BNSF still uses a large fleet despite age and more recent purchases. No. 4706, delivered in 1997 in Santa Fe Warbonnet red and silver with BNSF lettering, leads an intermodal towards Barstow, CA, on 7 April 2014.

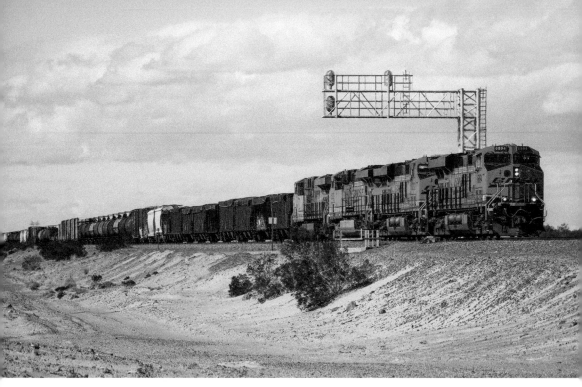

10 February 2019 sees No. 6894, an ES44C4 from 2012, leading an eastbound manifest train at Cadiz, CA. These trains don't maintain the high speeds of more important intermodal services and will often be seen sidelined in passing loops while the intermodals overtake. The freight cars include hoppers, tanks and classic box cars.

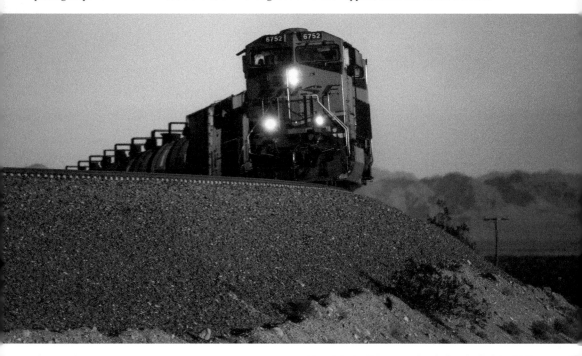

A powerful shot of ES44C4 No. 6752 rounding the high curve at West Siberia, CA, on a train of oil tanks during sunset on 30 January 2017. Note the use of a box car as a barrier between last locomotive and first tank – a common practise to reduce the risk of stray sparks from the locomotive exhaust or brakes igniting any oil spillages on the tanks.

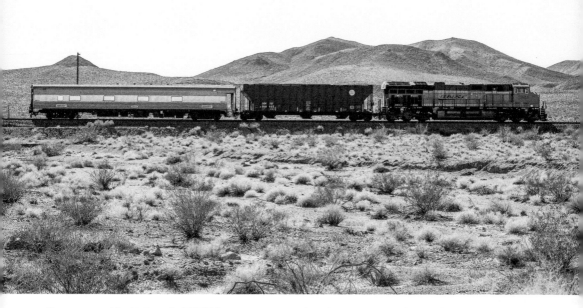

Passenger car No. 90 from the BNSF fleet is an unmanned track geometry recording car, built in 1946 by Budd for passenger service on the Richmond, Fredericksburg & Potomac Railroad. It was extensively rebuilt by the BNSF at Topeka, KS, in 2015 to make it suitable for its current duty. It is seen at Ludlow, CA, with a single hopper and ET44C4 No. 3844 on 30 January 2017.

With day rapidly turning to night, an eastbound Trans-Con intermodal disturbs a bird of prey from its telegraph pole perch at Cadiz, CA, on 10 February 2019. Eagles and turkey vultures are common in the area and often eat creatures hit by trains in addition to those they hunt. The area also hosts many snakes, rattlesnakes being the most prevalent.

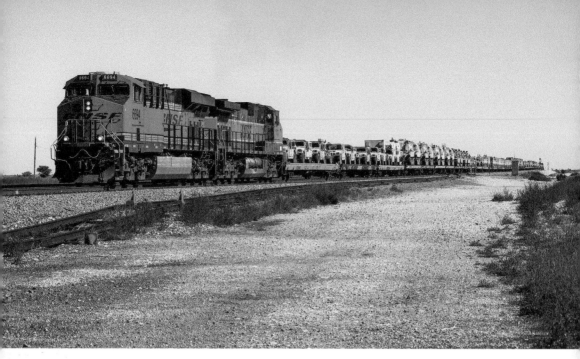

The US military is a major customer of the railroads; equipment can often be seen moving around the country by the trainload. Seen at Yeso, NM, on 27 October 2017, this westbound load included tanks and jeeps on flat cars and was powered by ES44C4 No. 6694 and C44-9W No. 1122.

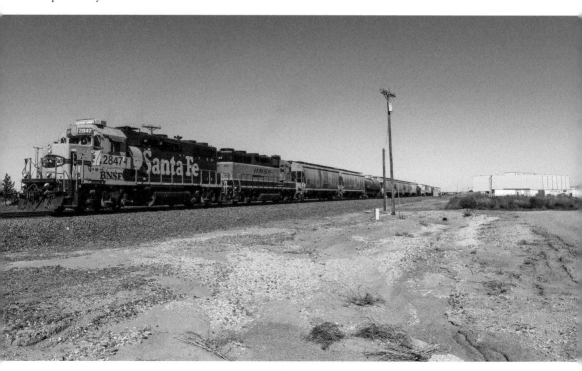

This local train from Clovis, NM, has just completed a collection and delivery to this meat plant near Friona, TX, a method of working lost to the UK many years ago but still prevalent in the US. On return to the yard at Clovis, the wagons will be sorted to the various manifests using the Trans-Con. 27 October 2017.

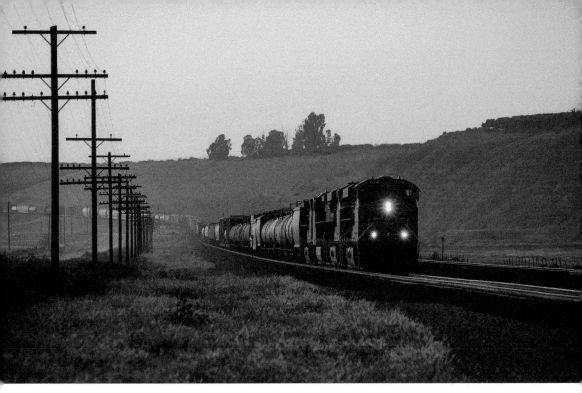

The golden sunsets across the far southern tip of California's Central Valley give superb opportunities for twilight photography of trains on their way to or from the Tehachapi Mountains. The clear evening of 28 February 2016 lights the way for this southbound manifest approaching Bena Corral.

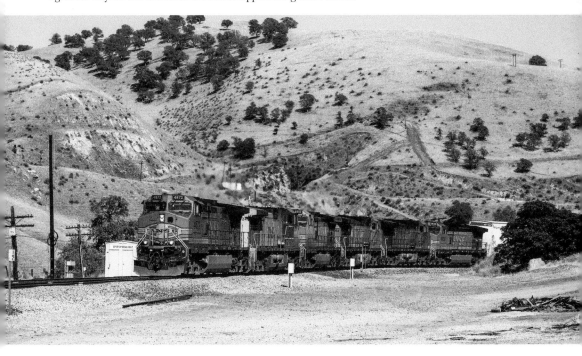

Early spring greenery has given way to parched brown hills at Bealville, CA, on 7 July 2013. Most of the rainfall in the area is from December to March; usually by May the change in scenery colour has become apparent. This train of reefers is led by C44-9W No. 4872.

The world-famous Tehachapi Loop at Walong, CA, has in recent years become very difficult to photograph; a combination of access restriction and tree growth has caused the loss of most of the viewpoints. This view of a southbound on the outside of the spiral, taken on 29 June 2013, is now partly obscured.

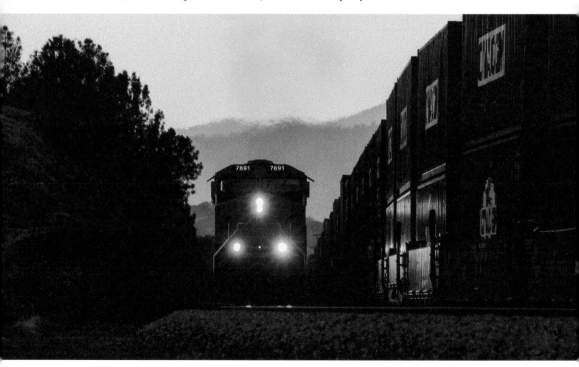

Twilight at Keene, CA, on 6 July 2013. No. 7891, an ES44DC from 2010, will be at full stretch on the front of its southbound train for some time – 15 miles with a ruling 2.5 per cent gradient lies between it and the summit beyond the City of Tehachapi.

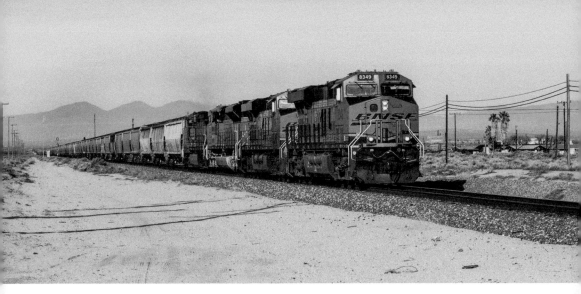

This long train of hoppers was caught racing through the desert at Boron, CA, on 4 March 2016 with ES44C4 No. 8349 on point. Much of the 70 miles of track between Mojave, 25 miles behind the train, and Barstow are straight and flat, allowing trains to maintain constant speed.

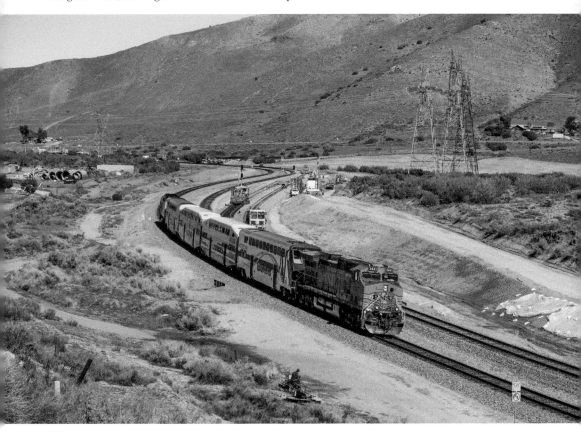

A Metrolink train hauled by a BNSF AC4400CW on former UP track. No. 5641 leads train No. 220 from Lancaster, CA, to Los Angeles Union on 8 March 2016, passing recently completed double-tracking work at Acton. Metrolink hired around forty of these units in late 2015 for a one-year period to cover for driving car unavailability.

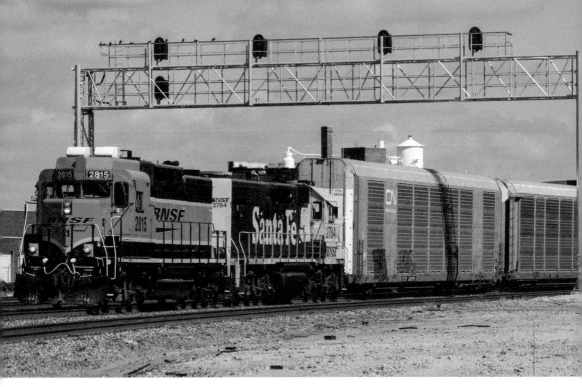

Veteran GP39-2s leading auto-racks through the West Bottoms area of Kansas City, MO, on 27 September 2015. Leading loco No. 2815 dates from May 1963 and was new to the Burlington Northern. Behind, No. 2784 was delivered to the ATSF in January 1975.

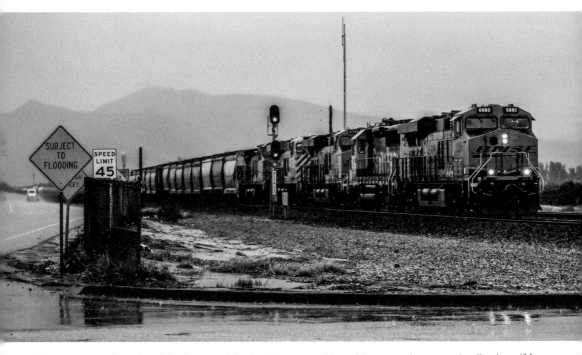

Heavy rain was the order of the day on 11 March 2016 as a northbound hopper train restarted at Sandcut, CA. Unusually included in the line-up is an elderly Bluebonnet GP50, No. 3175. Locomotives such as this are generally only seen on this type of traffic if they are being transferred between duties.

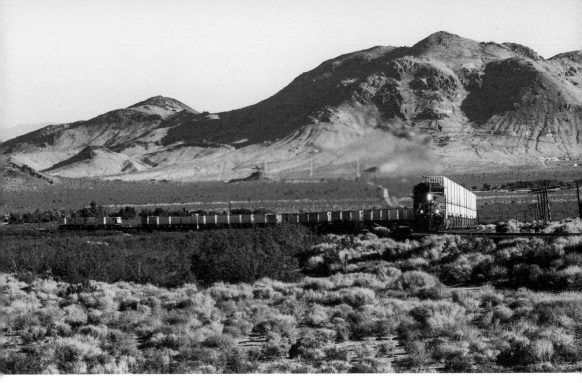

The most important intermodal trains sometimes carry both stacked containers and trailers on flat cars. Often refrigerated, the trailers will be carrying time-sensitive goods such as fresh meat or produce. This northbound train at Warren, CA, on 24 June 2012 is a couple of miles into its climb to Tehachapi.

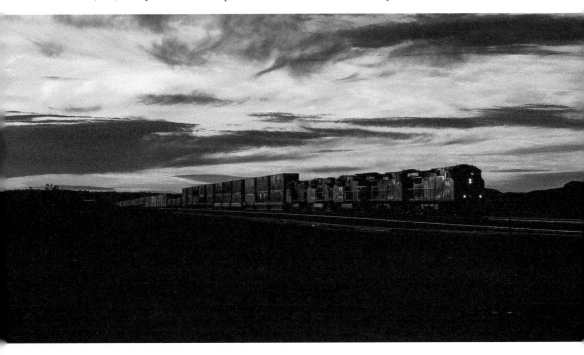

The last rays of the day highlight cloud formations above Daggett, CA, on 10 March 2016 as an eastbound intermodal gets into its stride for an overnight run along the Southern Trans-Con. With the distances involved in US railroading, it's not uncommon for a train to take three days to complete its journey.

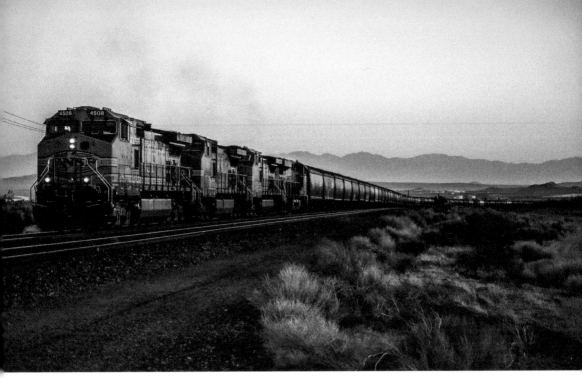

The term 'earthworm' is used by railfans to describe the long BNSF grain trains that use brown hoppers, and at around 140 hoppers and nine locomotives, they are long, heavy worms! This formation at Warren, CA, in the fading light of 15 September 2018 will be heading for Hanford or Stockton, in California's Central Valley.

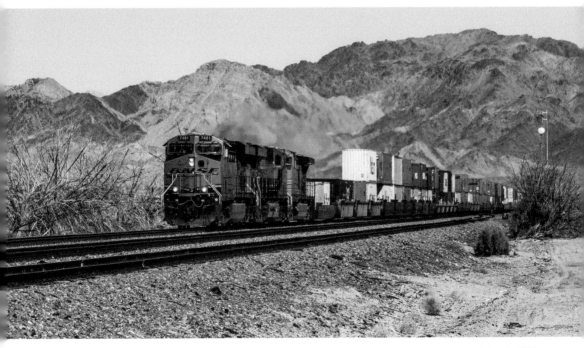

Led by ES44DC No. 7481, westbound double stacks pass the exchange loop at Cadiz, CA, on 7 April 2014. Returning freight cars from the Arizona & California Railroad are stowed in this loop until the BNSF collects them on the return working of the Cadiz local for forwarding from Barstow.

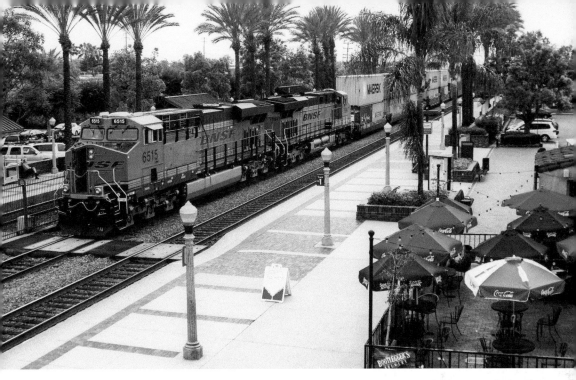

Around 25 miles from Los Angeles, the city of Fullerton is a busy railroad town, served by Amtrak and Metrolink passenger service and passed by many freight trains. The crew of ES44C4 No. 6515 has taken the opportunity to refill the drinks cooler at the station café while awaiting a slot forward onto the Trans-Con. 11 July 2013.

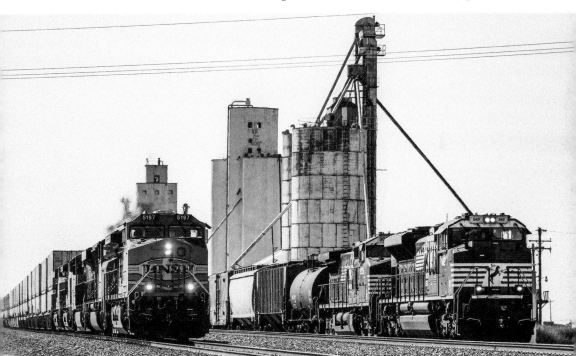

Locomotives from three railroads feature in this shot at Black, a little to the north of Friona, TX, on 28 October 2017. The BNSF eastbound intermodal has a Union Pacific SD70M behind its lead unit, while the Norfolk Southern is represented by an SD70ACe-led manifest. Both are BNSF trains; the NS units are returning home after BNSF use.

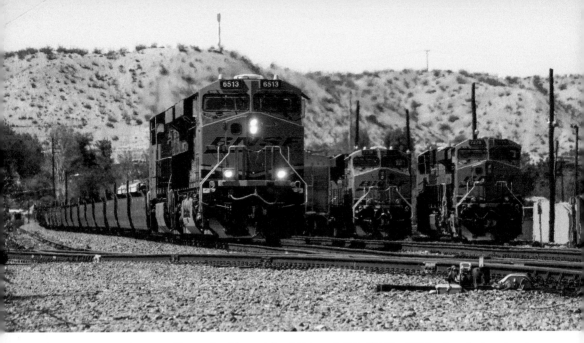

A high-horsepower line-up at Victorville, CA, on 3 April 2014 with ES44C4 No. 6513 heading for Los Angeles with empty well cars. To the right is the small yard, with locomotives on hand to collect bulk cement trains from several nearby plants.

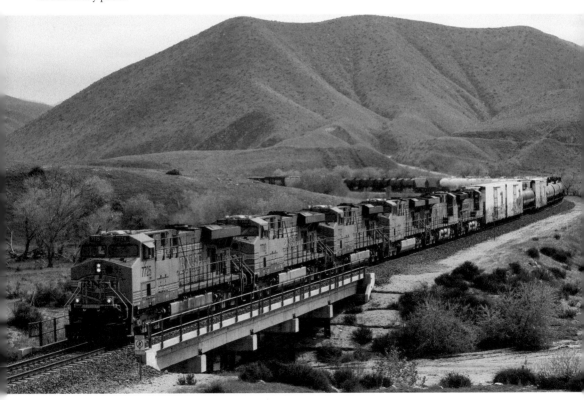

The rare sight of six locomotives from the same batch at work together. Nos 7725, 7700, 7707, 7712, 7717 and 7747 are all ES44DC locomotives dating from 2005 and are seen at Ilmon, CA, with a manifest heading north on 28 February 2016.

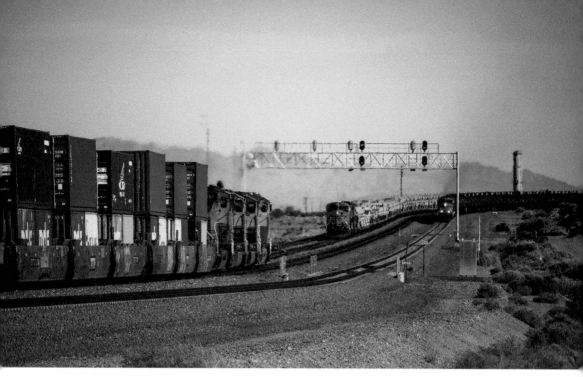

A busy moment on the incline between Nebo and Daggett, CA, with a military train waiting to enter the United States Marine Corps base at nearby Yermo. To the right, a train of oil tanks has arrived westbound on the Trans-Con while the Union Pacific train of stacks will shortly regain UP tracks to head north through Las Vegas to Salt Lake City. All are seen on 31 January 2017.

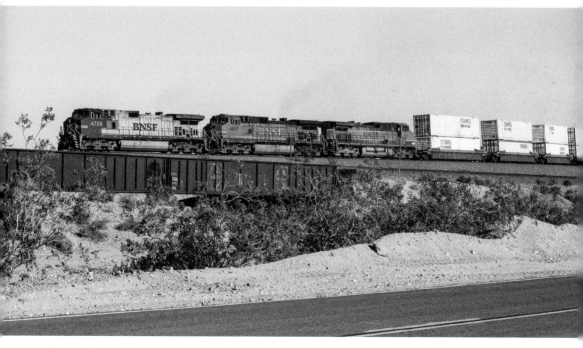

Intermodal trains are generally the preserve of newer, high-horsepower locomotives, but the unexpected can and does happen, leading to the use of older units. Three elderly C44-9Ws, Nos 4706, 4917 and 978, round the West Siberia, CA, curves on 7 April 2014. No. 4706 was ordered by the ATSF but delivered to the BNSF after the 1996 merger.

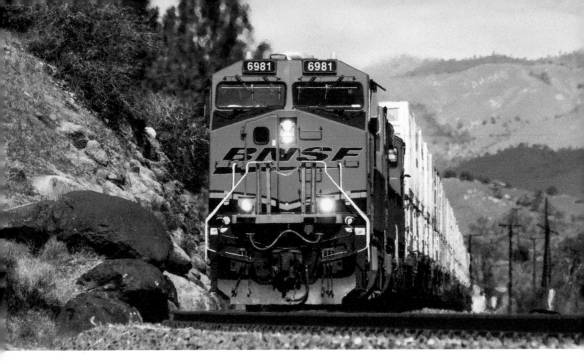

The long climb from Caliente to Tehachapi is typified at Keene, CA; 2.5 per cent gradients and long sinuous curves take the tracks up into the Tehachapi Loop and Mountains on a route built by Chinese labour in the 1870s. Despite being Union Pacific-owned, the route is of huge importance to BNSF operations in the western USA.

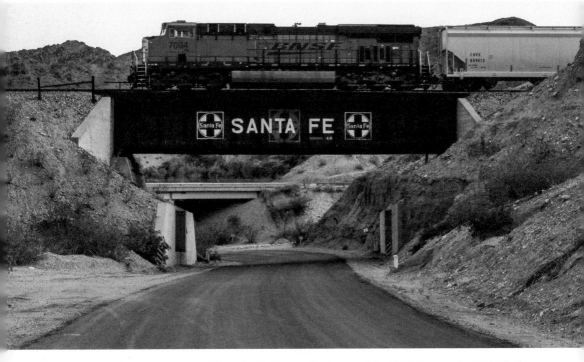

Nearly a quarter of a century has passed since the Burlington Northern and the ATSF became the BNSF Railway, but reminders of the past are still commonplace. This Santa Fe-branded bridge at Topock, CA, is typical of hundreds, maybe thousands, of similar structures all over the country; the railroads were always keen to make their presence known.

With its high elevation, the state of New Mexico has little to block its golden sunsets from view. In this scene from 27 October 2017, two double-stack intermodals pass on the high plains that surround Fort Sumner, reputedly the town in which outlaw Billy the Kid was ambushed and killed.

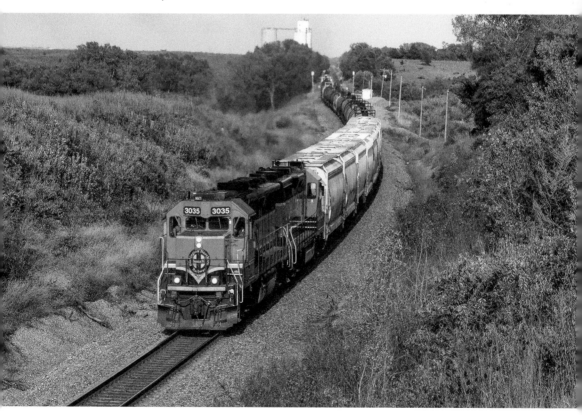

A warm afternoon of 28 September 2015 sees GP40X No. 3035 at Pleasant Dale, NE, leading a westbound local that originated in nearby Lincoln. Although in use as late as December 2018 in Seattle, WA, at the time of writing in April 2019 the locomotive was not on the active roster.

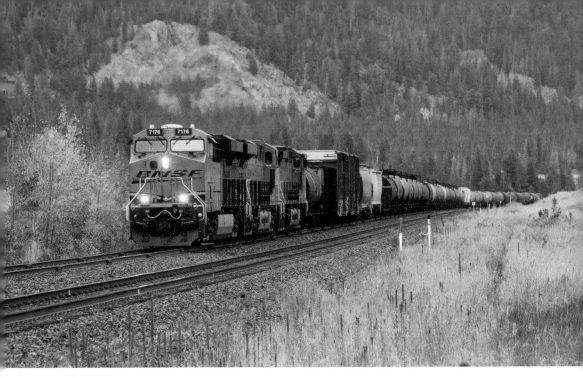

The unincorporated community of Tolland, in Colorado's Gilpin County, is a shade under 9,000 feet above sea level, high in the Rocky Mountains. Diesel locomotives lose efficiency at high altitude as the lower air density limits the intake for combustion, therefore reducing power output. Struggling for breath, three BNSF units use the UP-owned tracks on 3 October 2015.

Eastbound stacks and trailers on flat cars restart from a signal stop near Hidden Springs, CA, on 1 February 2017. The rear locomotive, GECX No. 2040, is a Tier 4 ET44AC demonstration unit in the blue livery of GE Capital Leasing.

SD70MAC No. 9793 shows off its green and cream BNSF Executive livery at Cadiz, CA, on 10 April 2014. An unusual visitor to the location, most of the type carried the livery from new. Some units have been repainted into standard fleet colours, but many SD70MACs are now due for age-related retirement.

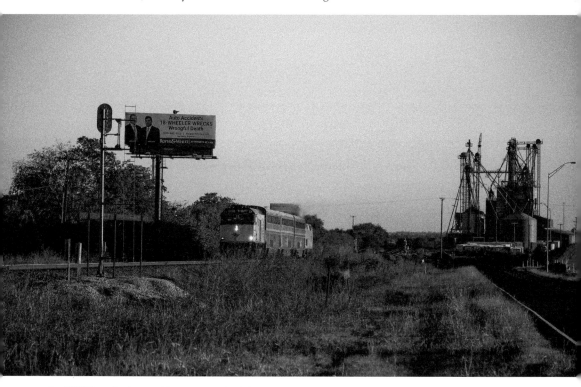

On BNSF track, the northbound Heartland Flyer passes Valley View, TX, with Cabbage Car No. 90222 leading on 17 October 2017. Cabbage cars (cab and baggage) are driving cars formed from former F40PH locomotives; the former engine compartment is now used for a checked baggage stowage area.

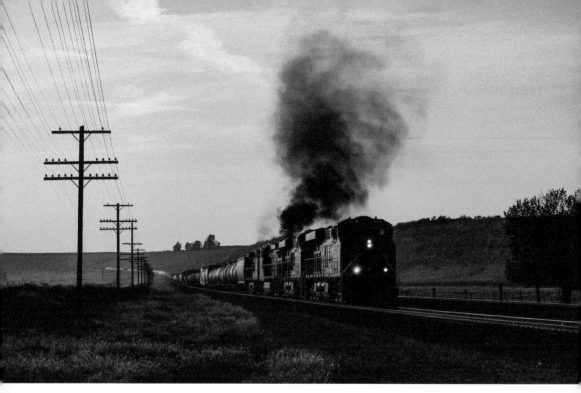

With one of its four units plainly not in the best of health, a southbound manifest restarts alongside Bena Road, CA, on 28 February 2016. While powerful and solidly reliable, the GE locomotive types in the US have a vulnerability to exhaust oil fires – many units bear scarred paint from previous minor outbreaks.

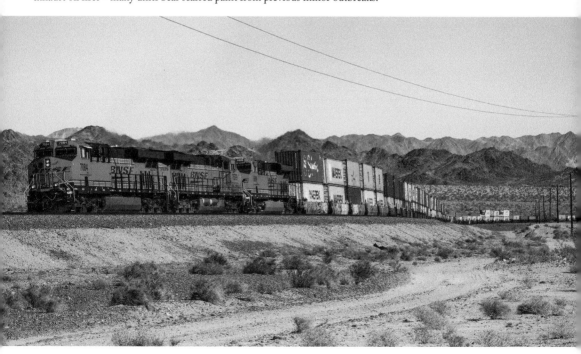

In a classic publicity shot pose, three Heritage III-liveried GE Evolution locomotives take a wide variety of intermodal containers up to Siberia, CA, on 4 February 2017. The containers on this load are international rather than domestic and will be bound for one of the West Coast ports for shipping.

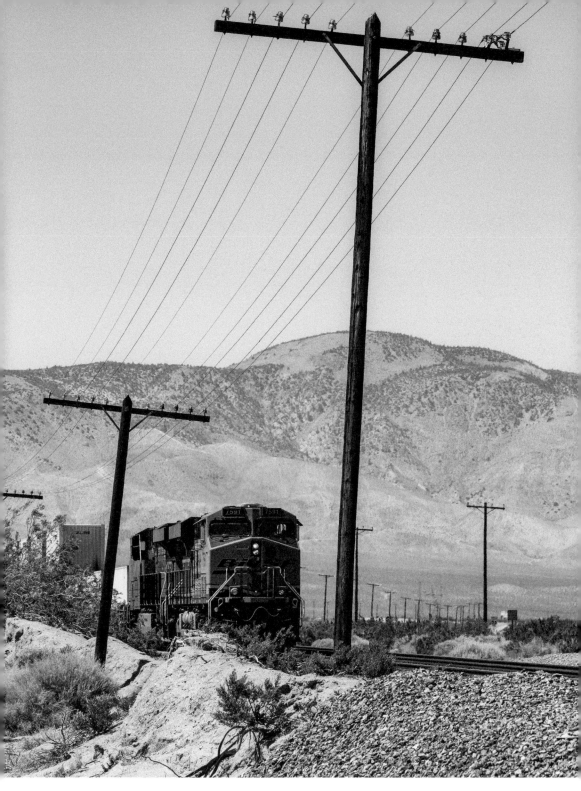

Redundant telegraph pole lines still stand trackside all over the US, the telegraph wire long since replaced by cab-to-shore radios and cellular technology. The wires here at Warren, CA, look to still be in reasonable repair on 21 June 2012; in many locations the old system is literally falling down.

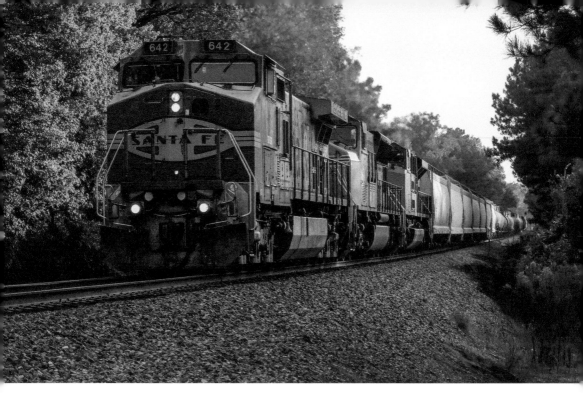

1994-built Dash 9-44CW No. 642 is seen here on hire to the Union Pacific, leading two EMD units at Jefferson, TX, on 19 October 2017. Close to the tri-state border of Texas, Louisiana and Arkansas, the train is heading for Texarkana, around 60 miles to the north.

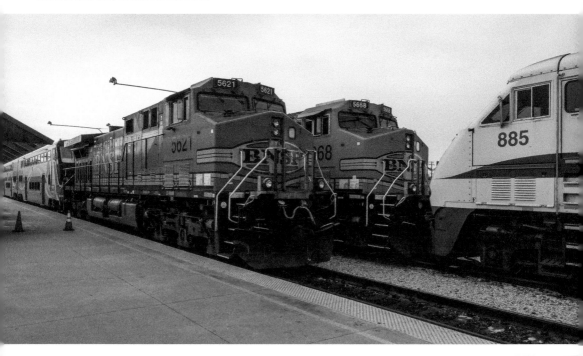

During the period in which Metrolink hired in a number of BNSF AC4400CW units, two of the type, Nos 5621 and 5668, share Lancaster, CA, Metrolink station with the more usual EMD F59PHI No. 885. This photograph was taken on Sunday 5 March 2016 as the trains await the Monday commute; few Metrolink trains run at weekends.

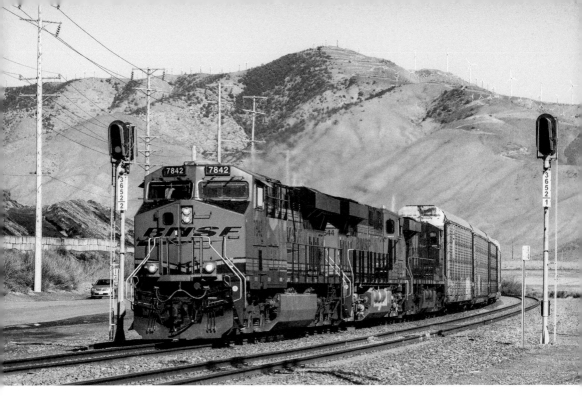

ES44DC No. 7842 leads a sister unit and a CSX hire-in on a train of auto-racks at Monolith, CA, on 30 March 2014. New in 2010, the ES44DC is one of the last batch of locomotives with DC traction motors delivered to the BNSF; all new locomotive purchases now have more efficient and powerful AC motors.

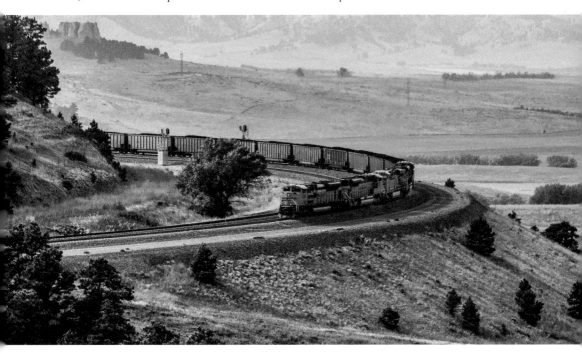

Four units on the rear of a loaded coal train at Crawford Hill, NE, on 1 October 2015. The two locomotives inside will be part of the train consist, two on the front and two on the back. The rearmost two are helpers attached at Crawford to bring the train uphill; they will be detached a few miles on at Belmont.

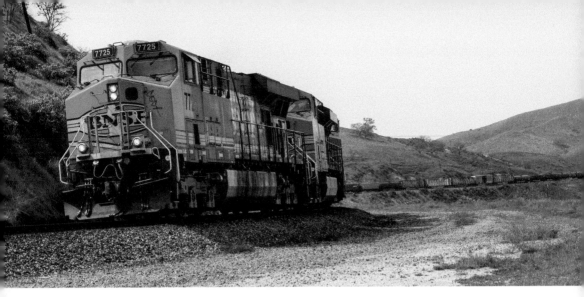

On the last stage of its descent from Tehachapi, ES44DC No. 7725 curves round and down into Caliente, CA, with a manifest train. At this point, the train will be making extensive use of the locomotive's dynamic braking capabilities, which use the traction motors as brakes – a feature common on US locos for many years.

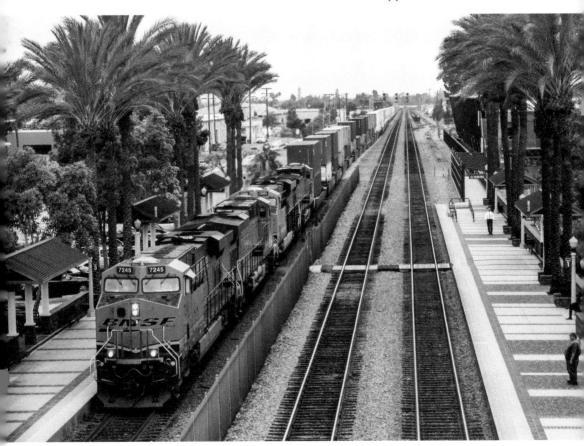

The station at Fullerton, CA, on 11 July 2013 with ES44DC No. 7245 leading a train of double stacks through the station. The fencing between the tracks is a recent addition; walking across tracks rather than using a bridge or subway is an everyday practise in the US, albeit one now being actively discouraged.

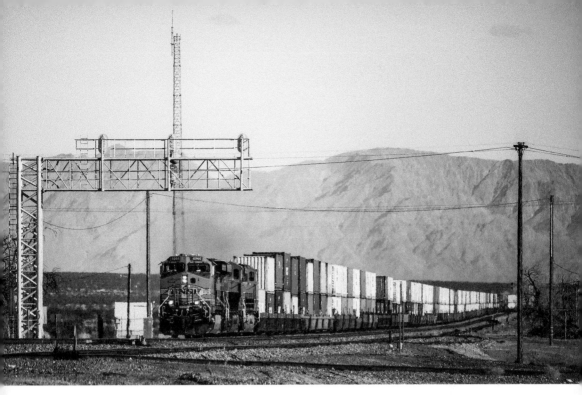

Classic Southern Trans-Con action at Amboy, CA, with C44-9W No. 4966 leading west on 10 February 2019. The BNSF was a big buyer of the GE Dash-9 locomotives and although many of the fleet are now approaching two decades of service, they continue to play an important role.

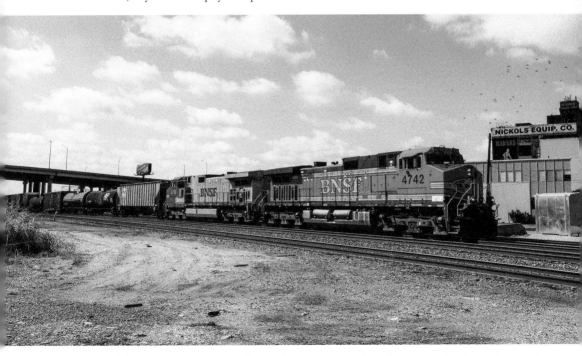

More Dash-9s. This picture from 27 September 2015 shows two units from the same batch, Nos 4742 and 4718, at Kansas City, MO. The red and silver Warbonnet-liveried No. 4718 was new around the time of the BN and ATSF merger and would have been painted before the deal was concluded.

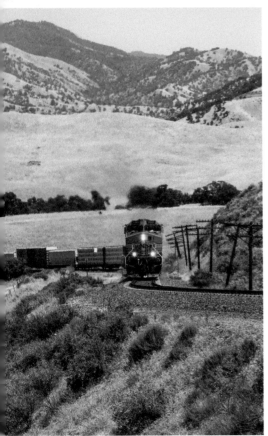

Above: Alongside the deserted Route 66 at Minneola, CA, a train of military hardware is close to its final destination at the Marine Corps base at Yermo. To reach the base, the train will reverse at Daggett to join the UP line north towards Las Vegas; the base lies around 2 miles north of Daggett. 1 February 2017.

Left: The Tehachapi Mountains loom large behind C44-9W No. 4387 on 23 June 2012. The train has climbed up from Caliente and is approaching Tunnel 2 on one of the single-track sections of the UP Mojave sub.

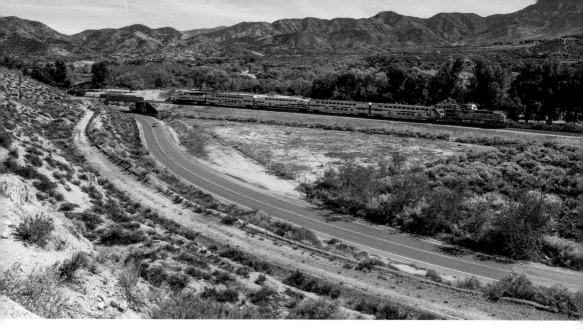

Ravenna, CA, is the location of this scenic shot of a BNSF-led Metrolink passenger service on 9 March 2016. Deep in the Soledad Canyon, the mountainous area that separates northern Los Angeles from the Lancaster plain, the train has recently crossed the notorious San Andreas Fault, known for its disruptive earthquakes.

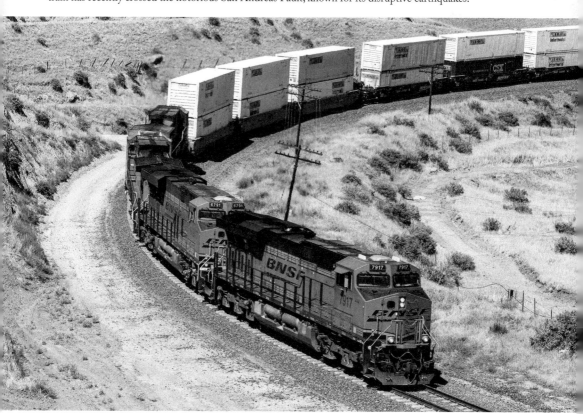

J. B. Hunt is an Arkansas-based transportation company and its familiar white containers are seen nationwide. A large operation with a $7 billion turnover, the company extensively uses rail to move both containers and semi-trailers nationwide for onward road distribution. A train of the company's boxes approaches Tunnel 2 on 23 June 2012.

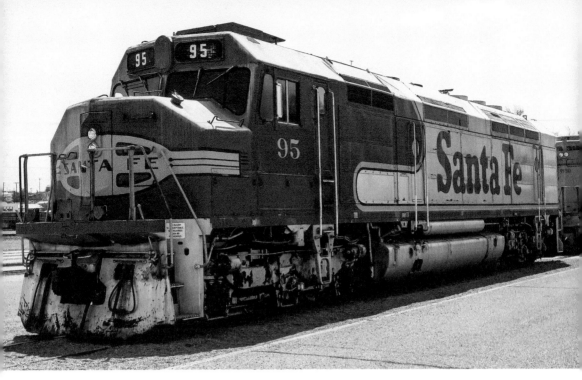

Dating from 1967, Santa Fe No. 95 is a retired FP45 unit, donated to and seen at the Western America Railroad Museum at Barstow, CA. The locomotive was one of the last passenger units built for the Santa Fe, which ceased passenger operations in 1971 and lasted in freight service until 1998. Seen on 4 July 2013, the museum has hopes of fully restoring the unit.

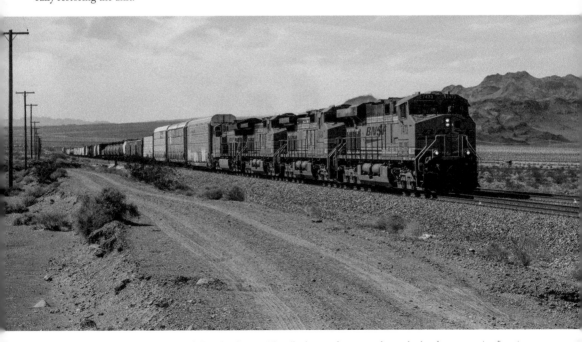

In between the important intermodals, a lowly manifest finds a path to run through the desert on the Southern Trans-Con at Ludlow, CA, on 10 March 2016. Headed by ES44DC No. 7473, it's likely the train will spend as much time sidelined to allow more important traffic to pass as it will in motion.

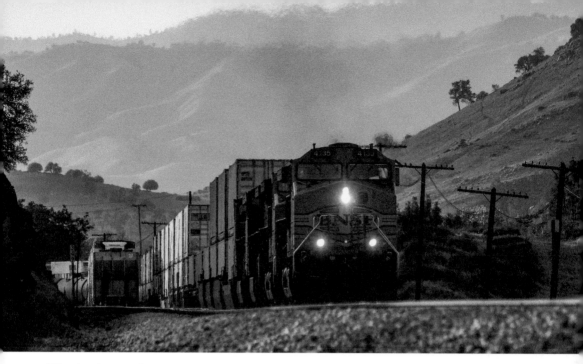

US railroads generally run to the right in the same manner as the highways; however, many of the main routes employ bi-directional signalling to allow traffic to continue during disruptions. C44-9W No. 4135 leads a southbound intermodal at Keene, CA, on the nominally northbound track on 29 June 2013; a northbound UP train occupies the southbound track in the distance.

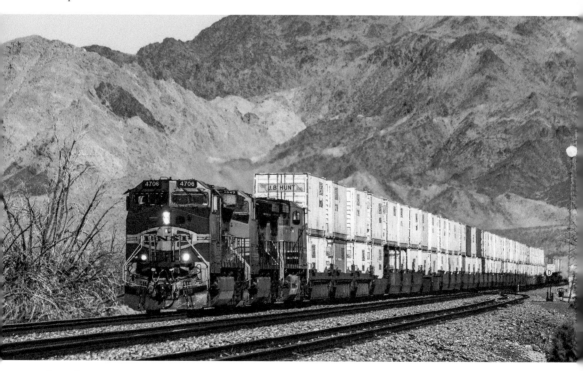

Superfleet survivor No. 4706, a C44-9W from 1997, leads a J. B. Hunt intermodal at Cadiz, CA, on 7 April 2014. At the time of writing in late March 2019, the locomotive still carries this livery, having never carried the orange-based schemes of the railroad that has owned the unit since new.

A relative newcomer to rail transportation, the now familiar blue 'smile' logo semi-trailers of Amazon.com are increasingly seen in the formations of trains across America. 1 February 2017 sees a train mainly composed of trailers on flat cars on the curves at West Siberia, CA, with a wide variety of trailers on board.

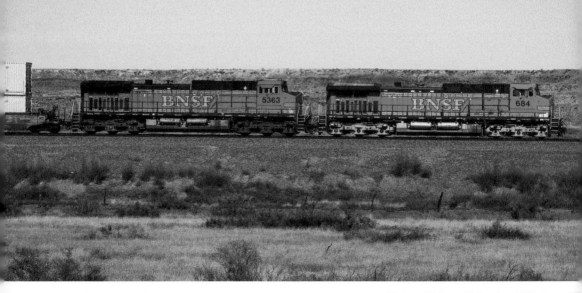

A pair of Heritage II-liveried C44-9W units, Nos 684 and 5363, running east at Taiban, NM, on 27 October 2017. No. 684 was originally delivered to the ATSF in 1994 while No. 5363 is among the last of the Dash-9s ordered by the BNSF and dates from 2001; the final deliveries of the type arrived in 2004.

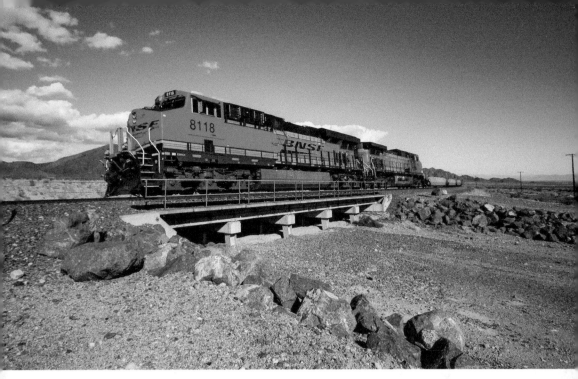

The hugely successful GE Evolution locomotives, often referred to as Gevos, are the mainstay of the modern-day BNSF Railway; the company employs over 3,000 units in several different specifications. No. 8118 is an ES44C4 from 2014, seen taking empty well cars west at Siberia, CA, on 9 February 2019.

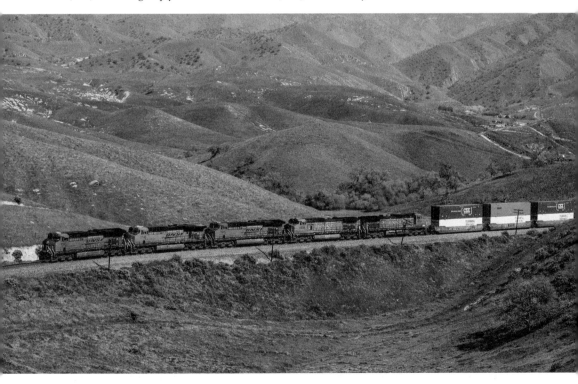

With three GE Evolutions and two Dash-9s up front, this southbound train of domestic stacks has nearly 22,000 hp to take it through the mountains as it curves towards Tunnel 2 above Caliente, CA, on 1 March 2016.

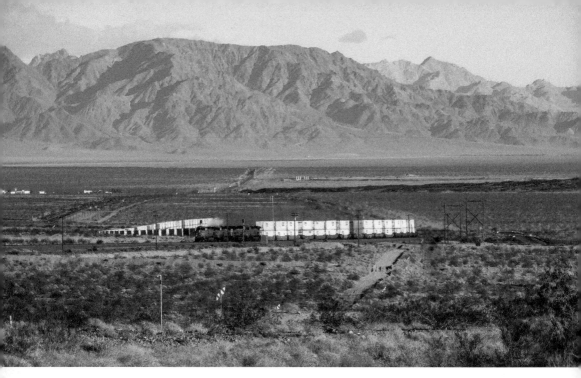

The view looking east from Bagdad, CA, on 24 January 2017. A westbound train of stacks approaches with the tracks stretching back into the distance. Cadiz, 20 miles away, can be seen way back; from there the tracks take a north-easterly course to avoid the looming mountains.

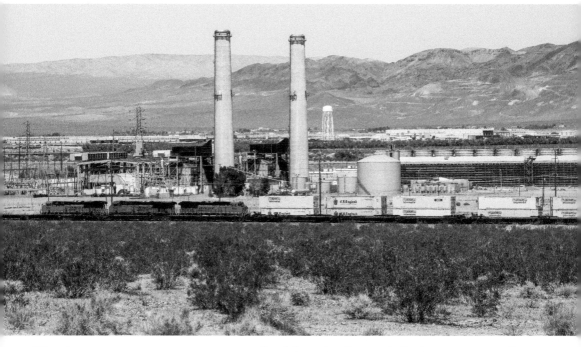

Many American power generation stations can be found alongside railroad tracks for the obvious reason of easy access for high-volume coal delivery. Cool Water generation station, near Daggett, CA, used its rail link for coal delivery but made coal gas to power its burners. Closed in 2015, a BNSF train runs westwards past the plant on 7 April 2014.

A few miles east of Cool Water, a westbound train of double stacks passes the tiny community of Minneola, CA, on 19 September 2018. The historic Route 66 cuts east to west through the area; before its arrival the area lay on the Mojave Trail used by pioneers and traders to California from the late eighteenth century.

Much of the track between Tehachapi and Caliente, CA, is single, the local geography making it both difficult and expensive to add a second track. At peak traffic times or during disruption this can cause train jams for miles around. This northbound was held at Eric on 31 March 2014, awaiting developments after a train stalled at Walong, 16 miles distant.

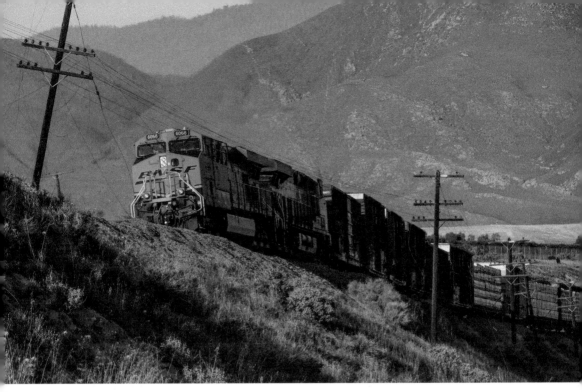

In the other direction, queuing trains trail frequently back towards Bakersfield. This 1 March 2016 shot at Sandcut, CA, shows ES44AC No. 6066 perched on a ledge at the rear of a southbound manifest. The train is waiting for permission to enter the single-track section through Caliente Creek.

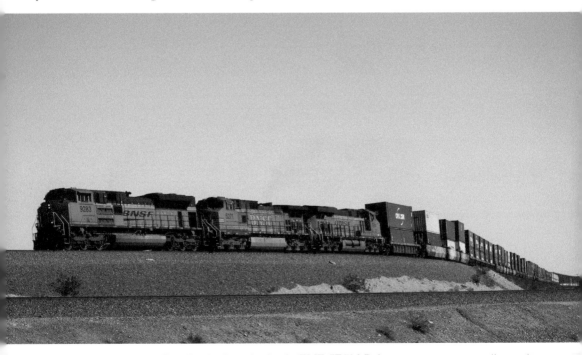

While acknowledged as a well-performing heavy hauler, the EMD SD70ACe locomotive is not universally popular with some train crews; there are sometimes complaints of reflections on the locomotive's windscreens. More recent deliveries have reverted to the previous cab design. No. 9283 leads at West Siberia, CA, on 10 February 2019.

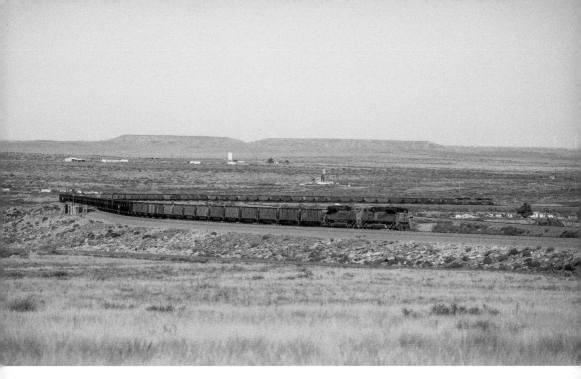

The BNSF SD70ACe is far more at home on the heavy coal trains through America's Midwest; this train rolling over the new Pecos River Bridge at Fort Sumner, NM, has two SD70ACe locos at each end. The picture was taken on 26 October 2017, a year or so after the new structure opened to traffic and removed another Trans-Con bottleneck.

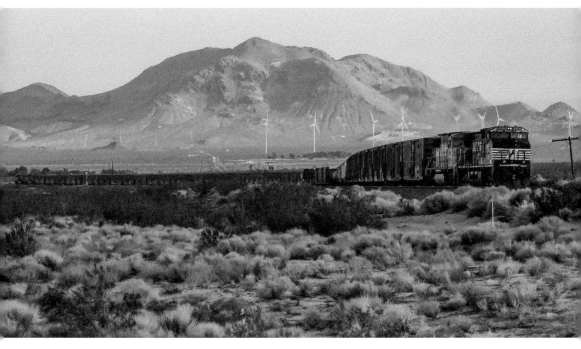

While not unknown, Norfolk Southern locomotives are not a common sight this far west on the BNSF system. On 2 July 2013, NS C44-9W No. 9807 is at the rear of a train about to turn east from Mojave, CA, to Barstow, along with another rarity in these parts, BNSF No. 9966, a rather faded SD70MAC from 1998.

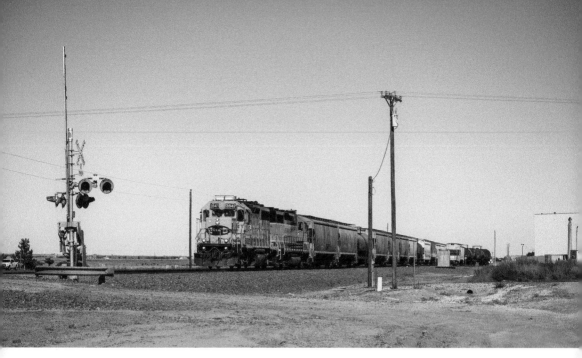

GP39s remain a popular choice for local workings all over the United States despite their age: BNSF units currently range between thirty-eight and fifty-seven years of service. Repainting lower tier and yard units hasn't been given much priority and many units still carry the colours of their pre-merger owners. Nos 2847 and 2814 drop wagons at Friona, TX, on 28 October 2017.

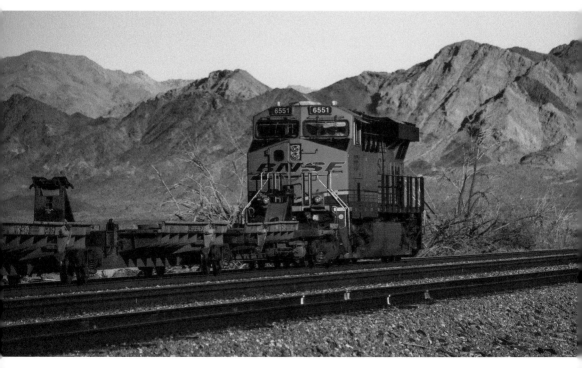

Riding solo on the rear of a long train of empty spine cars, ES44C4 No. 6551 passes Cadiz, CA, on the warm afternoon of 9 February 2019. Spine cars are used to transport semi-trailers, which use the same fifth-wheel coupling system to lock into place as they would to a tractor unit.

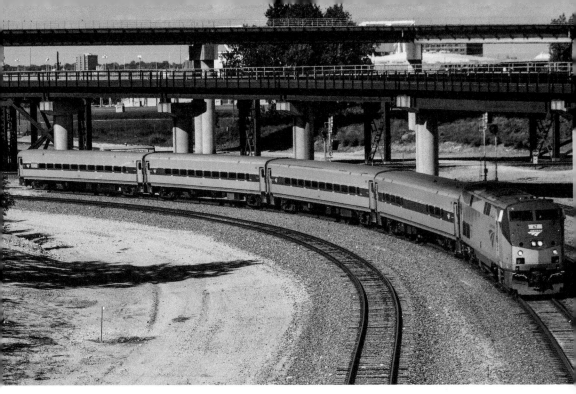

The twice-daily Missouri River Runner uses BNSF tracks along its 283-mile run from St Louis to Kansas City. Amtrak Genesis P42DC No. 67 and four Horizon passenger cars have arrived into Kansas City on the morning run south and are reversing using the curves at Santa Fe Junction before running back north at 4 p.m. on 27 September 2015.

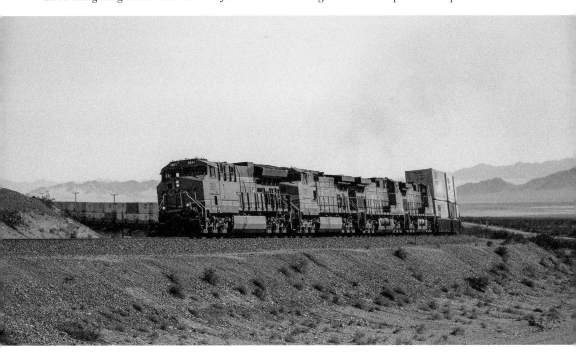

ET44C4 No. 3851 and three Dash-9s lead a westbound around the curve at West Siberia, CA, on 30 January 2017. Nominally running on the wrong track, the high-speed intermodal was using a lull in opposing traffic to overtake a slower-running westbound manifest which had passed a few minutes earlier.

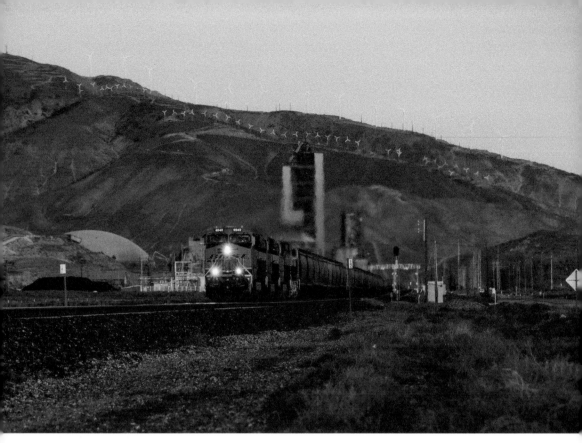

The grain 'earthworm' train that uses the UP Mojave sub generally passes through Tehachapi, CA, at dusk; the changing seasons only make around 90 minutes' difference to sunset time in California. Its climb from Mojave almost done, the train approaches Tehachapi Summit on 9 March 2016 with its usual formation of four locomotives on point, three cut into the middle and two at the rear.

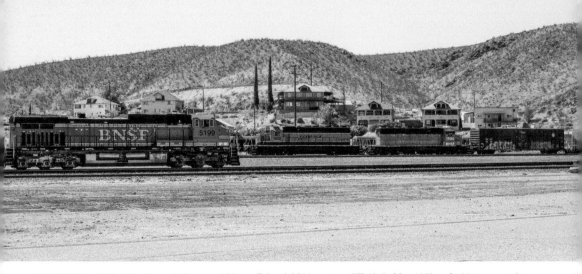

C44-9W No. 5199 drifts through Barstow, CA, on 7 April 2014, passing SD40-2s Nos 1859 and 1996 on switching duty in the East D Yard. Barstow is an important connecting point for the BNSF: access to and from much of America's west coast is available on the two westbound routes from the desert town.

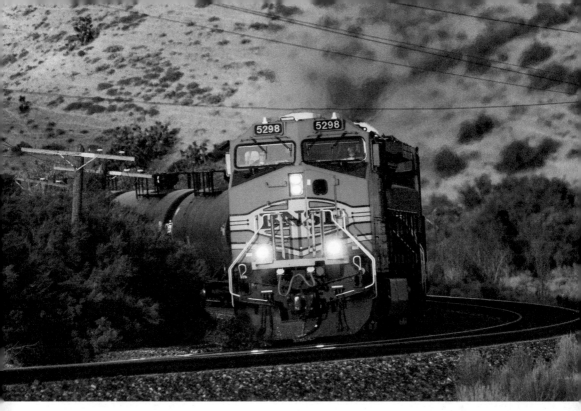

C44-9W No. 5298 catches the sun as its train of oil tanks rounds the sharp curve at Cameron Road, a track that goes into the mountains from Highway 58 a few miles east from Tehachapi, CA. Apart from the careful descent into Mojave, the next 80 miles of track into Barstow are easy going; trains such as this will race across the desert at or near their 70 mph limit.

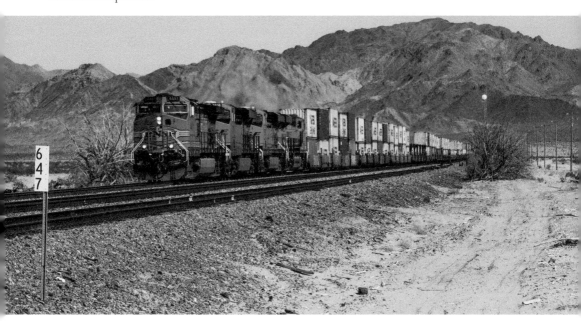

Milepost 647 on the BNSF Southern Trans-Con lies at Cadiz, CA; on this line milepost 0 is found at Belen, to the south of Albuquerque, NM. The westbound led by C44-9W No. 4491 will have travelled considerably further, originating from the BNSF logistics park at Edgerton, KS. 4 March 2016.

Golden hour at Barstow, CA. This Trans-Con train will shortly turn west and face directly into the sunset as it takes the route through the western Mojave Desert before heading north to the San Francisco Bay area.

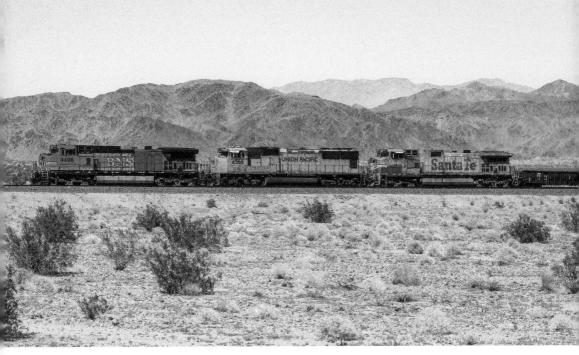

A side profile of the motive power for a train of empty well cars near Bagdad, CA, on 7 April 2014. C44-9W No. 4496 looks to have recent repairs, most probably after fire damage; borrowed UP SD70M No. 4566 follows with the rather battered-looking ex-Santa Fe C44-9W No. 643 in third place. Five years on, No. 643 still carries this livery.

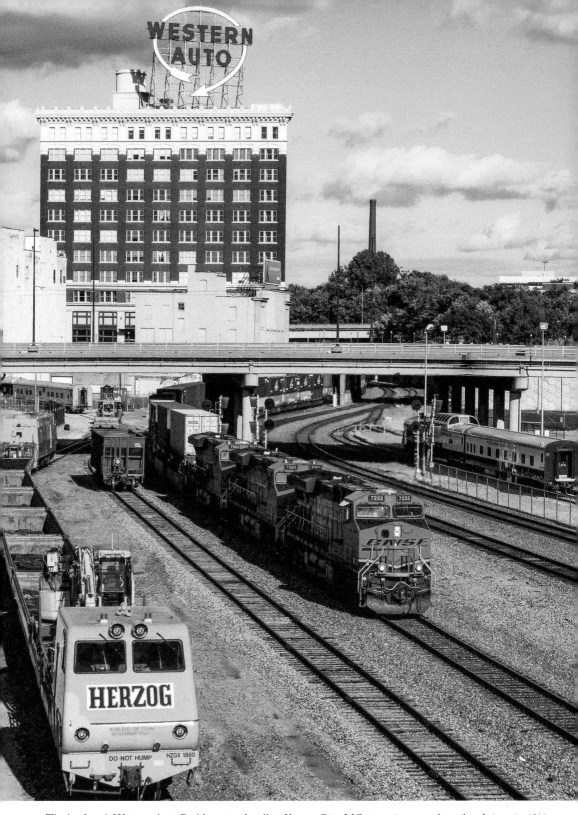

The landmark Western Auto Building stands tall in Kansas City, MO, towering over the railroad since its 1914 construction for the Coca-Cola Company. ES44DC No. 7233 leads a train west on 27 September 2015. Since the picture was taken, the sign has been restored to working order and is now illuminated at night.

An illustration of the Tehachapi Loop at Walong, CA; the four units leading the train are about to cross their own train, passing through Tunnel 9 beneath. Of interest is Canadian National unit No. 2506, a C44-9WL with older-style cab, a rare sight this far south on 29 June 2013.

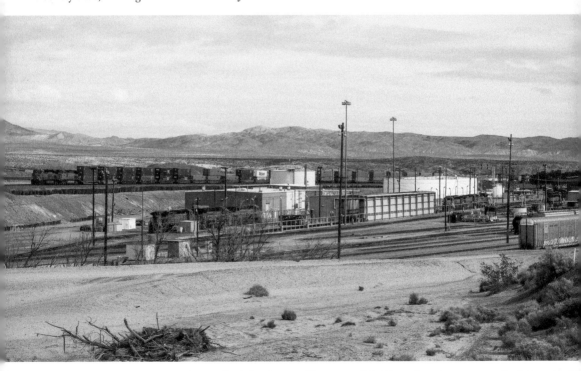

The western end of Barstow yard with its diesel shop is passed by a train of double stacks with two motors leading on 3 February 2017. Sadly, this view is no longer available as the BNSF has installed security gates further up the dirt track that leads down from Route 66.

The classic view of an eastbound at West Siberia, CA, on 18 September 2018. Four Evolution series locomotives lead, all under four years old at the time, giving the train around 17,600 hp of power. With the air temperature outside in excess of 100 Fahrenheit, the crew will be glad of the cab air-conditioning.

Late snow still caps the peaks of the Tehachapi Mountains on 2 April 2014 as an ES44C4 leads a duo of Dash-9s down towards Tunnel 5 near Bealville, CA. Before reaching the spot where the picture was taken, at Bealville grade crossing, the train will round a horseshoe curve and pass through another tunnel, Tunnel 3.

Another Barstow-operated local is the train to Boron, CA, which serves the large Borax mine. The daily service is a long-standing preserve of smaller units; the three SD40-2 locomotives in Heritage IV colours contrasted strongly with the green Burlington Northern-liveried GP39-3 as the train left the mine on 29 February 2016.

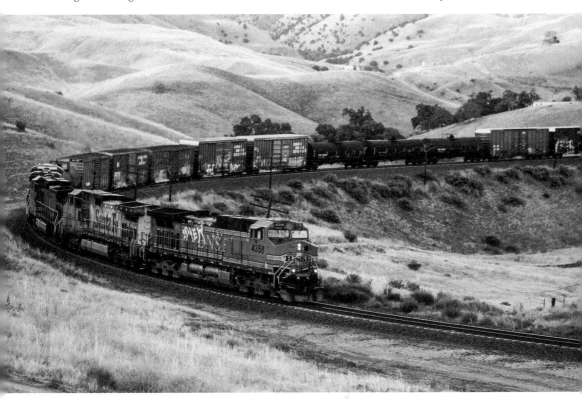

Much of the railway's rolling stock is prone to graffiti attacks; out of the large metropolitan areas the system is largely unfenced and unguarded. Locomotives tend to be attacked rather less than wagons as they have a crew aboard, but the taggers still caught up with C44-9W No. 4358, which is seen at Tunnel 2 on 23 June 2012.

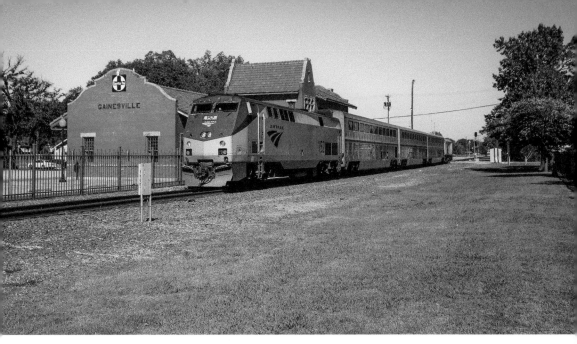

The smart former Santa Fe depot in Gainesville, TX, is served by the daily Heartland Flyer Amtrak service from Oklahoma City, OK, to Fort Worth, TX. On 19 October 2017, the southbound train calls at the station, powered by P42DC No. 152.

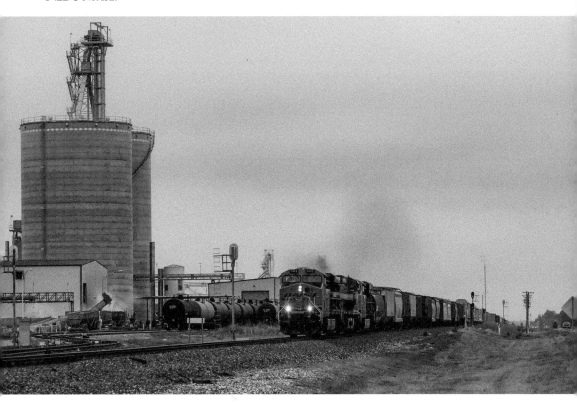

Under heavy skies on 5 October 2015, a southbound manifest passes Bridgeport, NE, on the former Chicago, Burlington & Quincy route to Denver, CO. Led by ES44DC No. 7472, the second locomotive in the formation, No. 4509, is an AC4400CW from the Kansas City Southern 'de Mexico' sub-fleet.

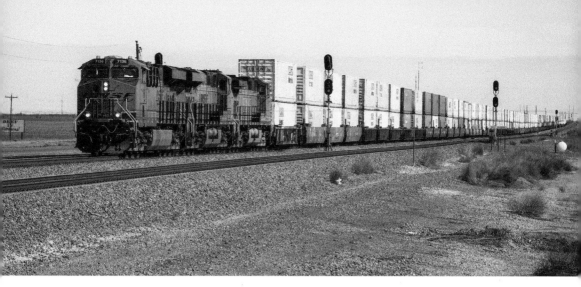

On the Southern Trans-Con in Texas, a well-loaded double-stack intermodal passes through the agricultural area around Friona on 29 October 2017. This north-eastern corner of Texas is home to many vast cattle ranches as well as fields devoted to grain and cereal cultivation.

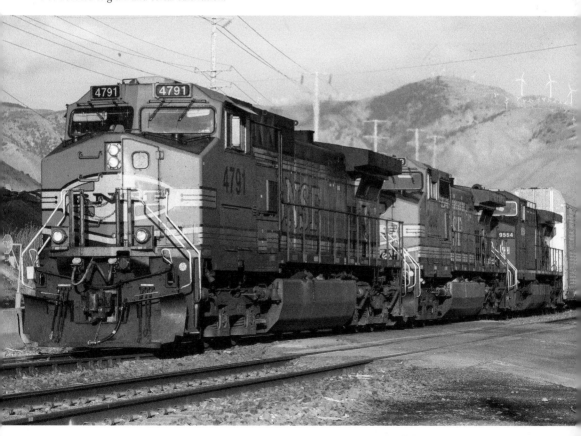

Powered by C44-9Ws Nos 4791 and 4809, assisted by Canadian National AC4400CW No. 9554, a train of auto-racks passes the grade crossing at Monolith, CA, on 31 March 2014. With constantly changing traffic needs, hiring of units between railroads is common and it's unusual to go a day without seeing foreign power.

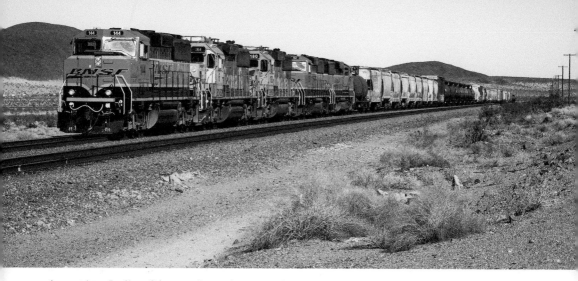

Approaching Ludlow, CA, on 18 September 2018, a five-pack of four-axle units leads the return Cadiz local back to Barstow. Long superseded by larger and more powerful units on front line duties, these smaller locomotives still serve the railroad on local and yard work and are an essential part of the fleet.

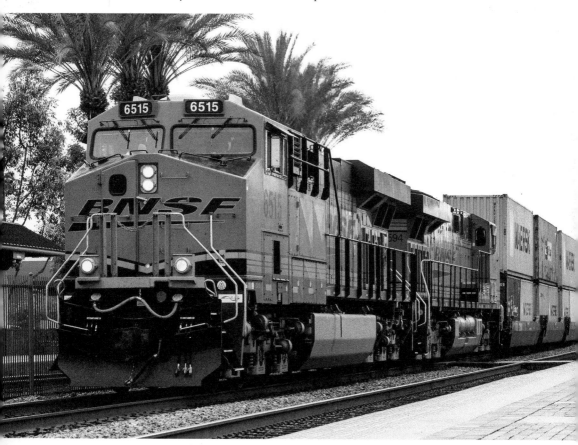

Under the palms on the platforms of the station at Fullerton, CA, ES44C4 No. 6515 and ES44DC No. 7594 prepare for a long run east on the Southern Trans-Con on 11 July 2013. Access to the cab is made via the steps and the door on the left-hand side of the nose with a separate emergency escape.

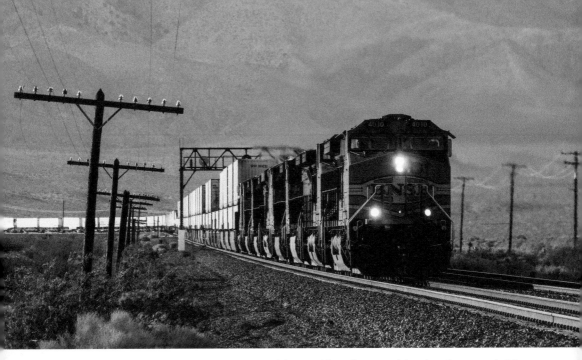

Passing under the now gone signal bridge at Warren, CA, a southbound intermodal with eight units is led down into the Mojave Sink by C44-9W No. 4010 on 5 July 2013. The BNSF operates a large fleet of C44-9W or Dash-9 locomotives, with around 1,700 in current use.

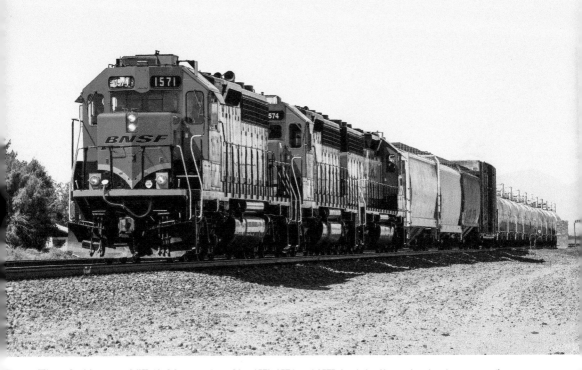

Three freshly painted SD40-2 locomotives, Nos 1571, 1574 and 1575, lead the Boron local as it prepares for return to Barstow, CA, on 3 April 2014. The old ATSF caboose kept at Boron for use during propelling operations on the mine's branch line has been detached and stowed ready for its next use.

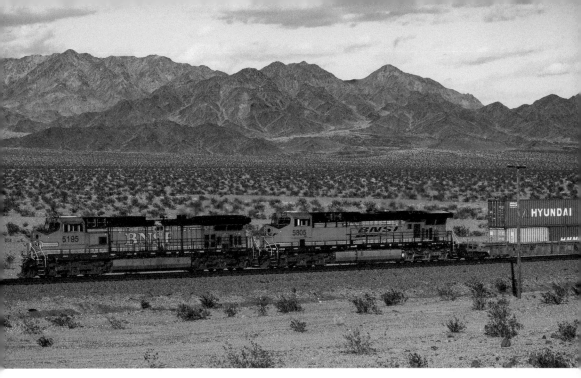

C44-9W No. 5195 leads ES44AC No. 5805 through the Mojave at Amboy Crater on 10 February 2019. Forerunner to the Evolution series units, the Dash-9 locomotives are externally similar to their younger cousins but differ considerably 'under the hood'.

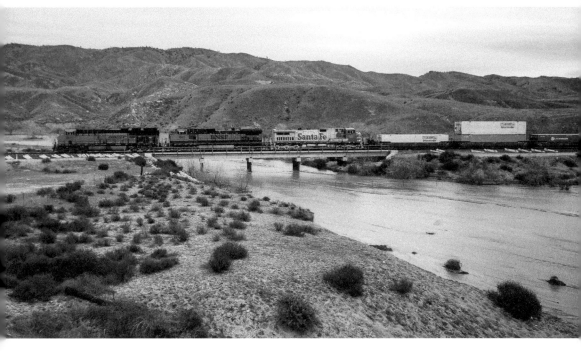

For all but around six weeks a year, the waterway that flows out of Haypress Canyon at Ilmon, CA, is a dry riverbed; only when winter snow on the surrounding mountains melts does it become a river once more. On 7 February 2017, a northbound train crosses the bridge, with ET44C4 No. 3917 leading two elderly C44-9Ws, No. 1062 and Santa Fe survivor No. 644.

Surrounded by the equipment and materials for track replacement work in the area, a southbound manifest draws through Bealville, CA, at dusk on 28 February 2016. Bealville was named for Edward Beale, a local ranch owner and district superintendent.

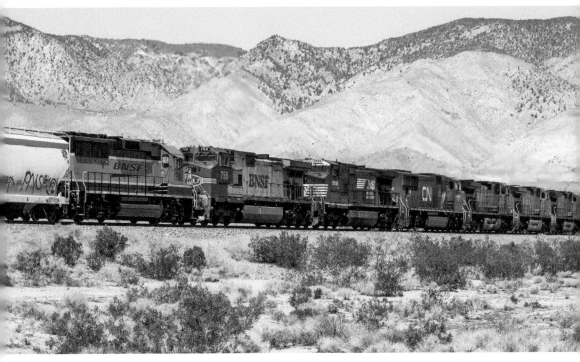

With six units under power and GP60 No. 169 hitching a ride, a northbound manifest train drags up the incline towards Warren, CA, on 6 April 2014. Three BNSF Dash-9s lead a Canadian National SD75I, a Norfolk Southern Dash-9 and an elderly ex-Santa Fe Dash-9. The CN SD75I is a particularly rare visitor to southern California.

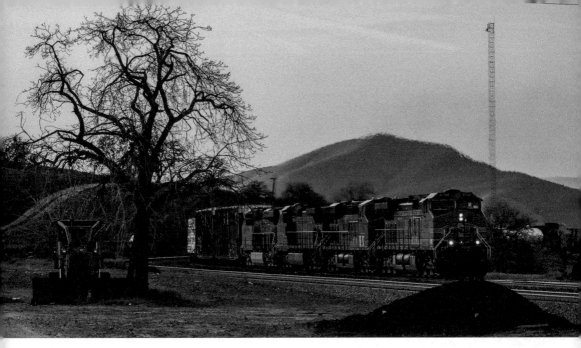

Another view at Bealville, CA: in the orange sunset of 1 March 2016, another northbound manifest runs through the passing siding located here. With nothing approaching in the other direction, C44-9W No. 4384 has a clear run at the steep incline ahead; it is common to see a train waiting here for a northbound to clear the single track through Tunnels 3 and 5.

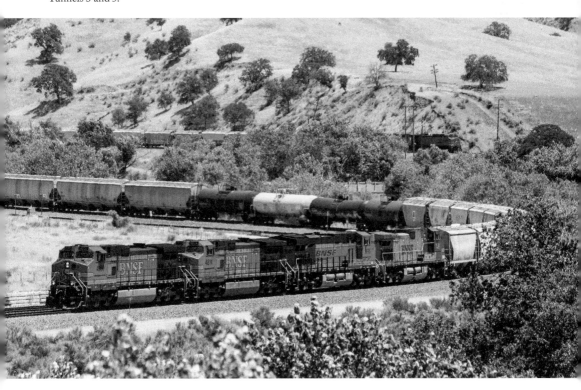

The horseshoe curve at Caliente, CA, provides the opportunity to photograph both ends of a train of the right length. This northbound manifest passing on 23 June 2012 fitted perfectly with a four-pack of GE motors leading and two more units bringing up the rear.

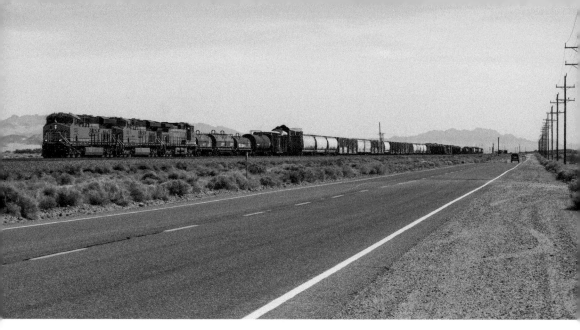

Route 66 railfanning at Hidden Springs, CA, on 4 March 2016 with ES44C4 No. 6533 leading a very mixed collection of freight cars west towards Barstow. This normally very quiet section of the 66 parallels the railroad for many miles; the road builders followed the easy gradients of the railroad where possible.

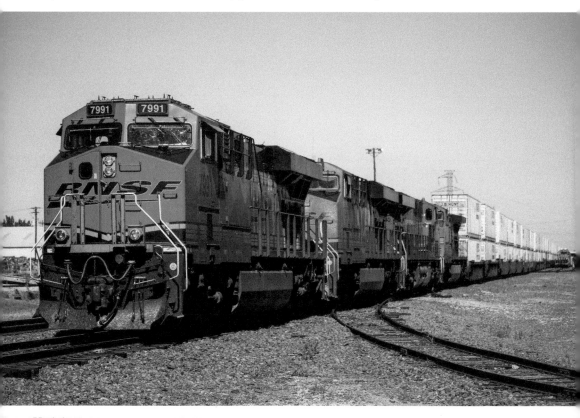

High horsepower on point with ES44C4 No. 7991 leading double-stack J. B. Hunt containers through Gainesville, TX, on 18 October 2017. The lead locomotive is a Tier 4 emissions credit locomotive, one of a batch of seventy-eight units.

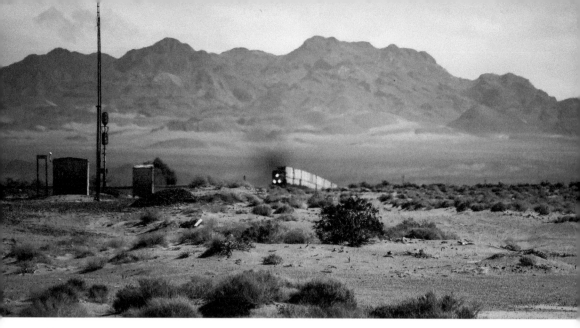

The remoteness of the Mojave Desert is displayed in this moody shot of a westbound train of double stacks approaching East Pisgah, CA, on 10 February 2019. The train is still around a mile and a half away but can still be clearly seen and heard.

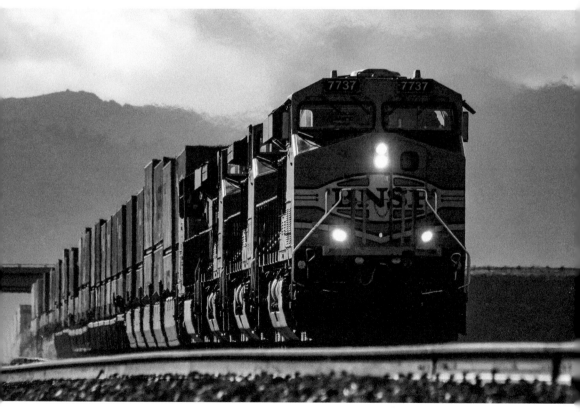

The heat haze rising from the four-pack of units heading this train at Tehachapi Summit is testament to the work they have done in the last 20 miles; the much easier, albeit careful, descent down to Mojave lies ahead. ES44DC No. 7787 leads on 30 March 2014.

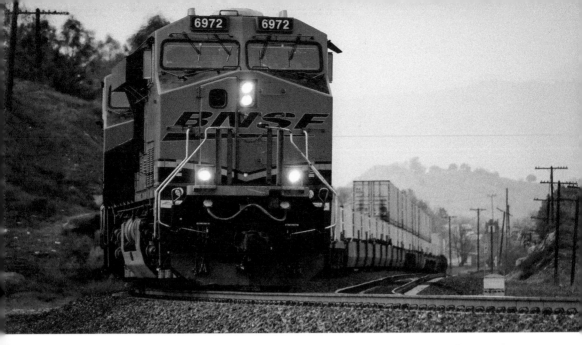

There aren't so many wet days at Keene, CA, but when it does rain adhesion on the 1 in 40 gradients can become tricky. ES44C4 No. 6972 and three more units were struggling to grip the wet rails as they took a long but relatively lightly loaded intermodal south on 3 March 2016.

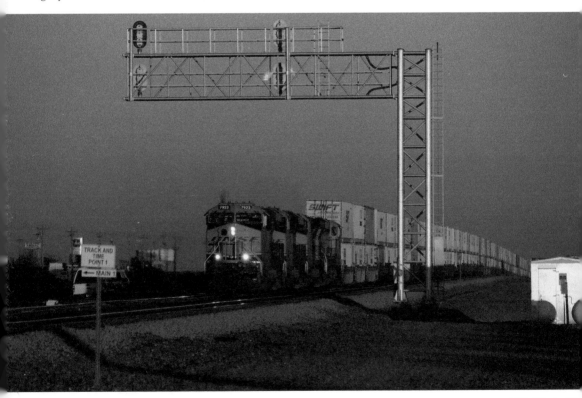

The stunning New Mexico sunset of 26 October 2017 greets ES44C4 No. 7923 leading westbound stacks down the hill into the yards at Clovis. There are extensive yards and holding sidings in the town; many trains are held here for crew changes and traffic regulation.